Mari I'Anson's

Finchley Sketchbook

Regards!
Mari I'Anson

CONSERVE · ENHANCE · EDUCATE · INFORM ·

THE FINCHLEY SOCIETY

Published by The Finchley Society
www.finchleysociety.org.uk

This publication has been supported by:
The Robert Winton Bequest.

Printed in East Finchley by:
JG Bryson Printer
020 8883 6648
www.jgbrysonprinter.co.uk

Dedicated to the memory of my parents

Jack and Kathleen I'Anson

who always encouraged me to draw

INTRODUCTION

FINCHLEY an artist's eye

Why Finchley? Well, Finchley has been my home for almost forty years and in that time I have seen many changes. The good, the bad, and the ugly.

But since I think positively, I dwell only on the good. And this book is all about the people and places that I see every day in which I find a wealth of personal subject matter for my sketchbook. I also delve into the history of Finchley and understand what it is that makes this part of North London such an easy place to live in. Halfway between urban city and countryside, with excellent public transport, it is well placed. So, it's not bohemian Hampstead, nor is it literary Highgate with charming hilly streets of elegant old houses, but it does have an interesting history and the changes that have come about recently have given the locality a new lease of life. What this book is about is not a history of Finchley. There are already several very interesting and informative books on the subject. What I want to do is to illustrate how drawings can depict what the camera does not. The fine detail of carved stone, the texture of brick or pebble-dash. I often try to work from a photograph, only to find that these details have been lost.

My passion for drawing buildings prompted this collection of illustrations, for I cannot look at a building that interests me without wanting to draw and paint it. During the summer when the trees are in full leaf it can be frustrating as many buildings are obscured and only in autumn can I see enough to draw, but then it is often too cold to stand around. I hope that the pictures will somehow reflect the sheer enjoyment of the artist as observer.

Roaming the streets with my sketchbook I see houses with character that have survived modern development. These drawings become a starting point for my illustrations. For instance, there are still many homes with original features, stained glass front doors, sash windows, pargetting and decorative tiled roofs.

In East Finchley, the old village still has charm, the High Road shops with corner buildings that have decorative turrets on their roofs. The busy North Finchley shopping area where architecture of a bygone day can be seen above many shops and is not often noticed by the public. Taking a bus ride on the upper deck will enable one to view it all.

A PRIVATE VIEW

I started drawing at my father's knee. Literally. I remember sitting on his lap when I was around two years old and watching him transform a piece of paper into a pram by drawing it. I was fascinated by this metamorphosis. Where there had been a sheet of paper there was now a pram. It looked so real. It seemed truly magical and I dearly wanted to be able to do it myself. From then on my curiosity and need to draw encouraged my parents to provide an unending supply of art materials: paper, pencils, paints and sketchbooks. On holiday as I grew up I would fill sketchbooks adding written notes and did once write and illustrate a children's book when I was about six.

I left school at the age of fourteen and started studying at a small art school in Somerset run by a husband and wife who taught me everything I needed to know about drawing and painting. I left after four years and came to London where I worked in fashion drawing and illustration. My clients included advertising agencies and publishers, giving me the experience of the widest range of work available.

TRAVELS WITH A SKETCHBOOK

After holidaying at an art centre in Tuscany where I started painting the local scenery in acrylic and watercolour, I began exhibiting my work and my career took off in a different direction. But I always sketched and my trips abroad gave me every opportunity to fill sketchbooks and keep visual diaries. In India I sat and drew the Taj Mahal and the ruined temples, working under great difficulties with inquisitive children all pressing close to watch me work.

I travelled all over Thailand giving impromptu lessons to local kids in vilages, sharing my paper and pencils with them. In Mexico the bright colours of the local people and their houses made me use plenty of red and yellow.

One aspect you have to cope with is that you are always on show. You are watching and looking in order to recreate what you see, but you are also the subject of curiosity. People breathing down your neck while you work is not funny, nor the remarks that are made. I hope this collection of illustrations will give pleasure to those who live in Finchley and also to those whose have moved away and have fond memories of living here.

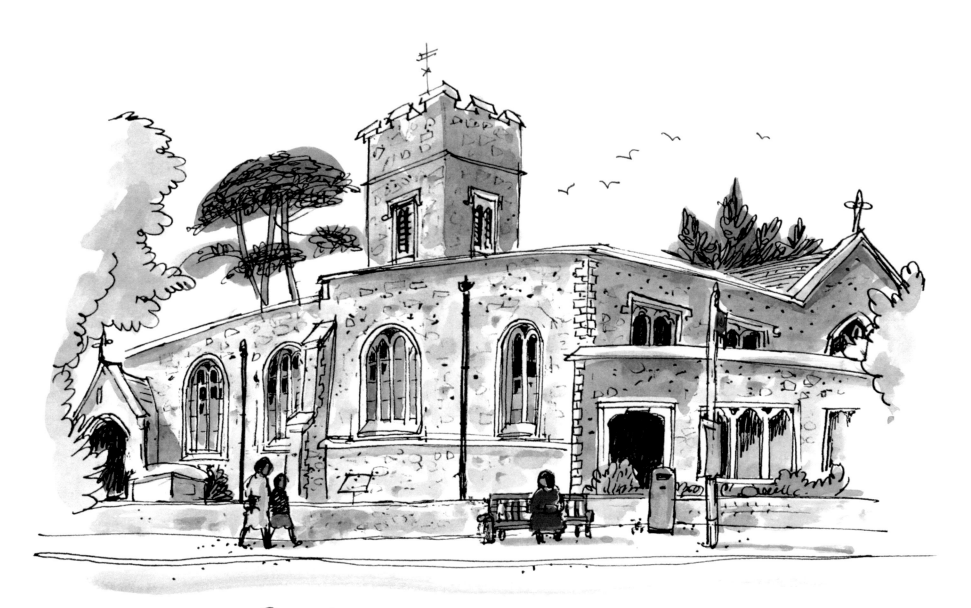

St. Mary at Finchley.
The oldest building in Finchley

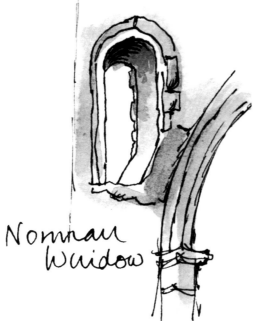

Here under lyeth the Bodyes
Of Sir Thomas Allen of Finchley
In the County of Midsx Knight
And of Dame Mary his Wife
One of the Daughters of Sr John
Weld late of Arnolds in the
County of Hartford
Knight
Shee Dyed
The 4th of Febr. 1663
Aged
Hee Dyed
The 18th of Augst 1681
Aged 79

The interior walls of the church are covered in many monuments to past residents of Finchley. Below, the memorial to Alexander Kinge and his wife Elizabeth. 1618

Norman Window

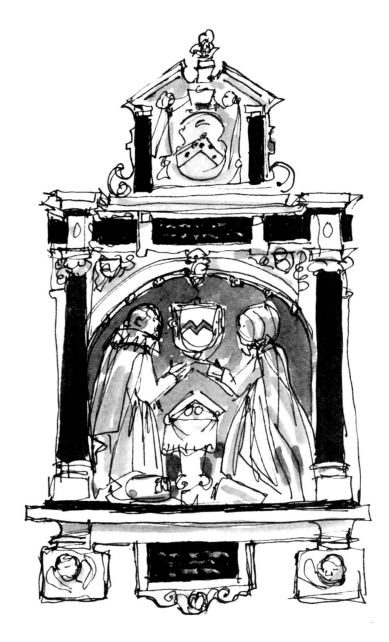

ST MARY-AT-FINCHLEY
The Parish church has stood on this ground for centuries.

Wandering around the churchyard I found these lovely old tombstones.
Some were covered in moss and ivy, but many have been cleaned, so I
could just read the inscriptions. The thick foliage and under-growth make
this a place of peace and an ideal habitat for birds. I was sad to see so
many babies' gravestones

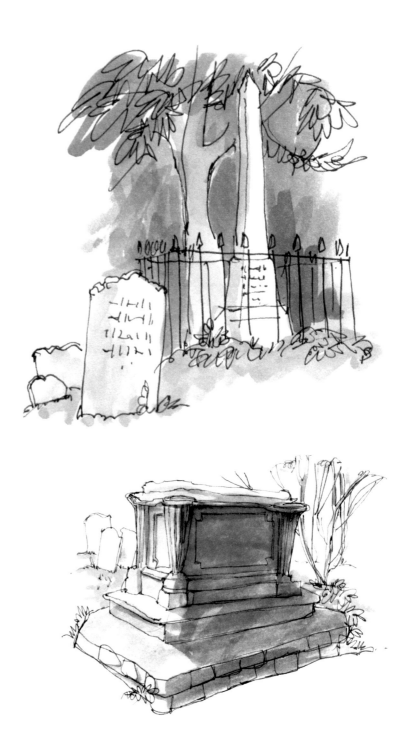

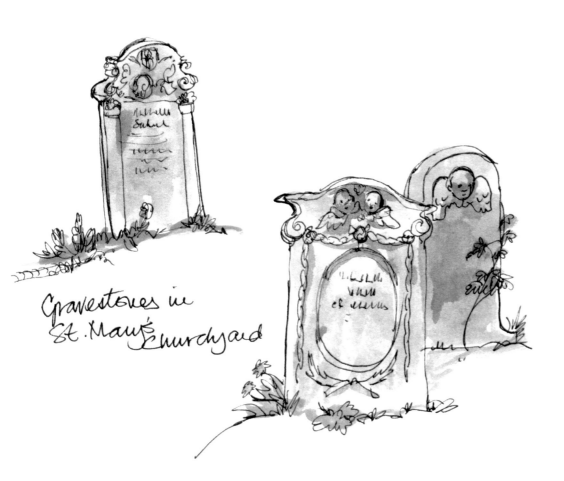

Gravestones in
St. Mary's Churchyard

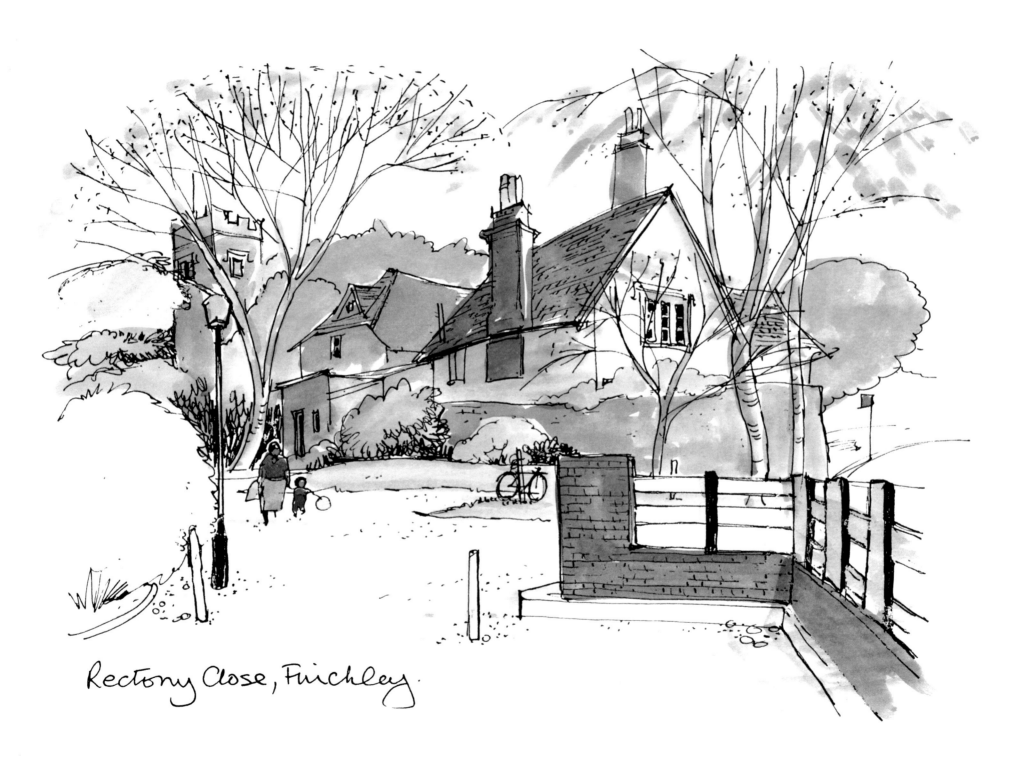

Rectory Close, Finchley.

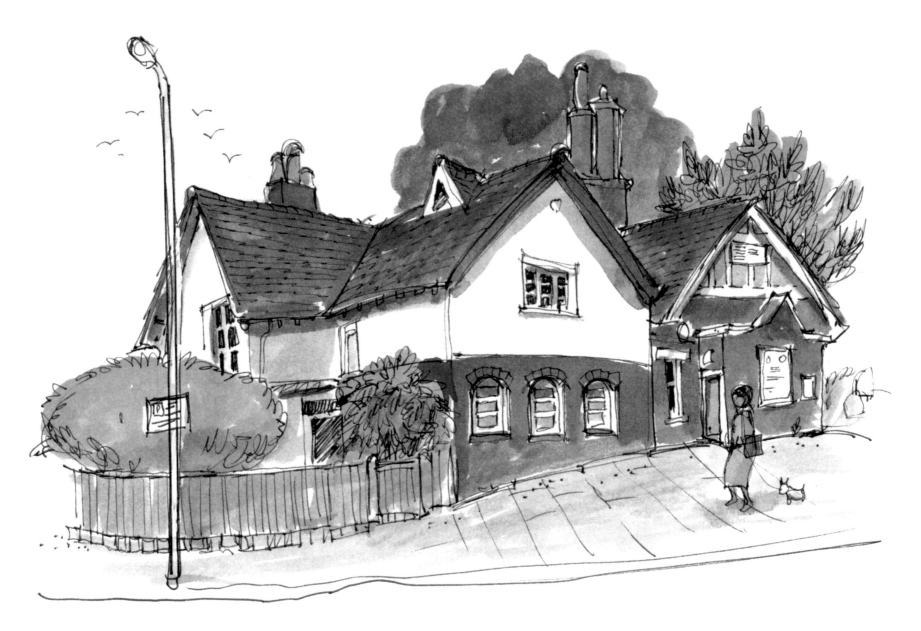

The quaint little house next door to the church has always fascinated me. It once housed the curate. The Blue Beetle Hall next door is used for meetings. I love the pepper pot chimneys and tiled roofs.

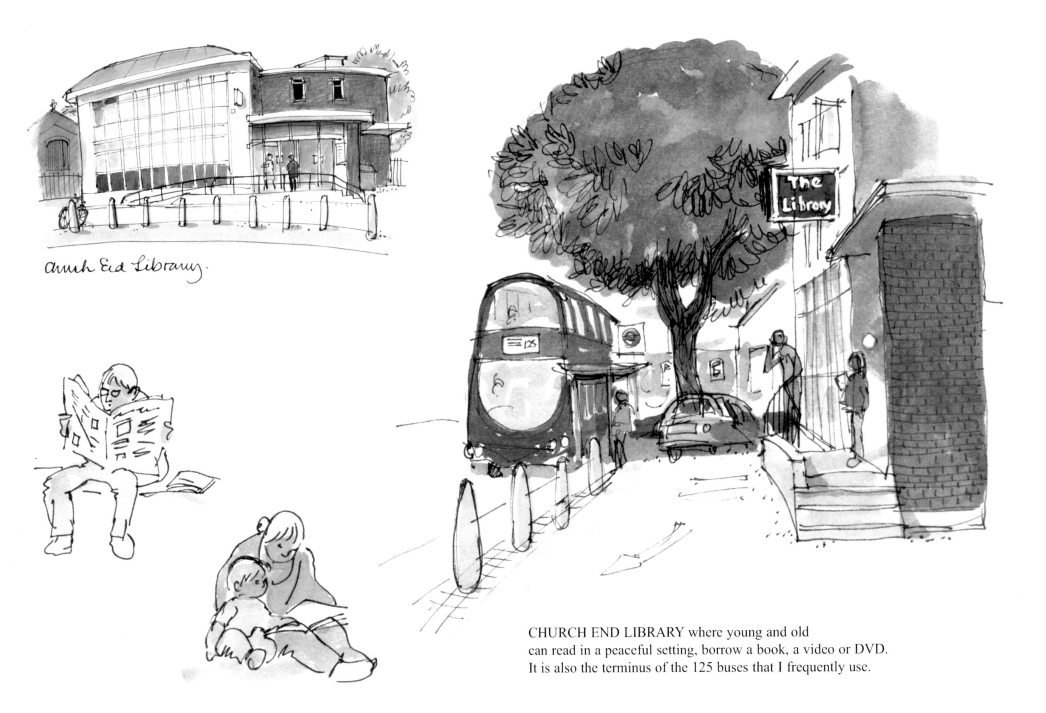

Church End Library.

CHURCH END LIBRARY where young and old
can read in a peaceful setting, borrow a book, a video or DVD.
It is also the terminus of the 125 buses that I frequently use.

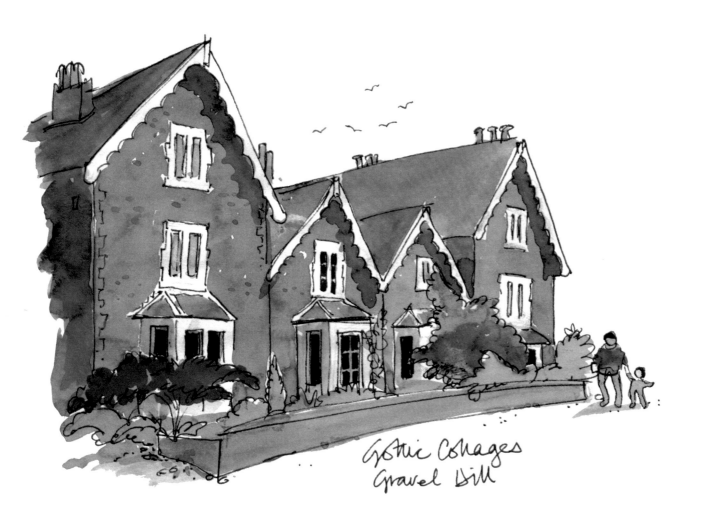

Gothic Cottages Gravel Hill

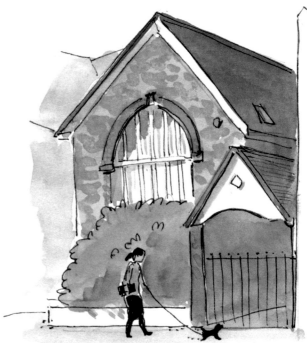

Hamilton Hall, Hendon Lane

Church End is the heart of Finchley and the area around St Mary's offers the artist a very wide range of subject matter. Victorian Gothic in Gravel Hill and Hamilton Hall in Hendon Lane are two good examples.

Moishe Bude House in Hendon Lane is a school for Jewish boys. The Victorian brick building once housed the local boys' grammar School. The distinctive green tower is a landmark and can be seen at a distance as you approach Finchley from the south..

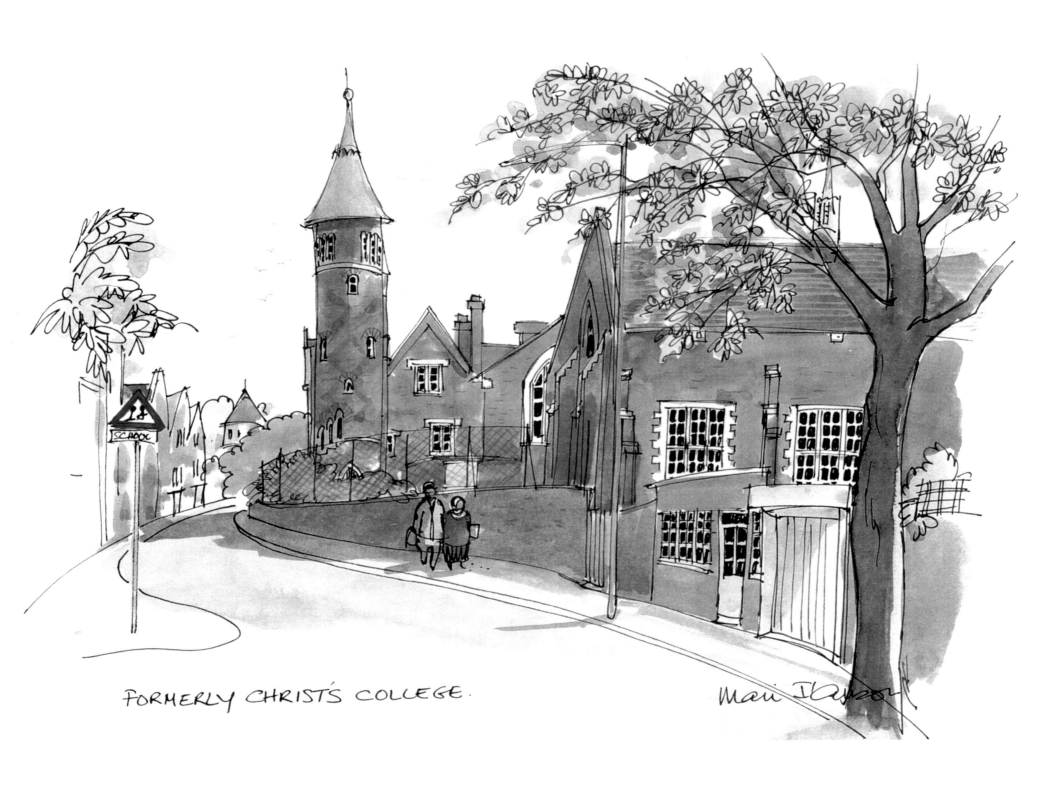

FORMERLY CHRIST'S COLLEGE.

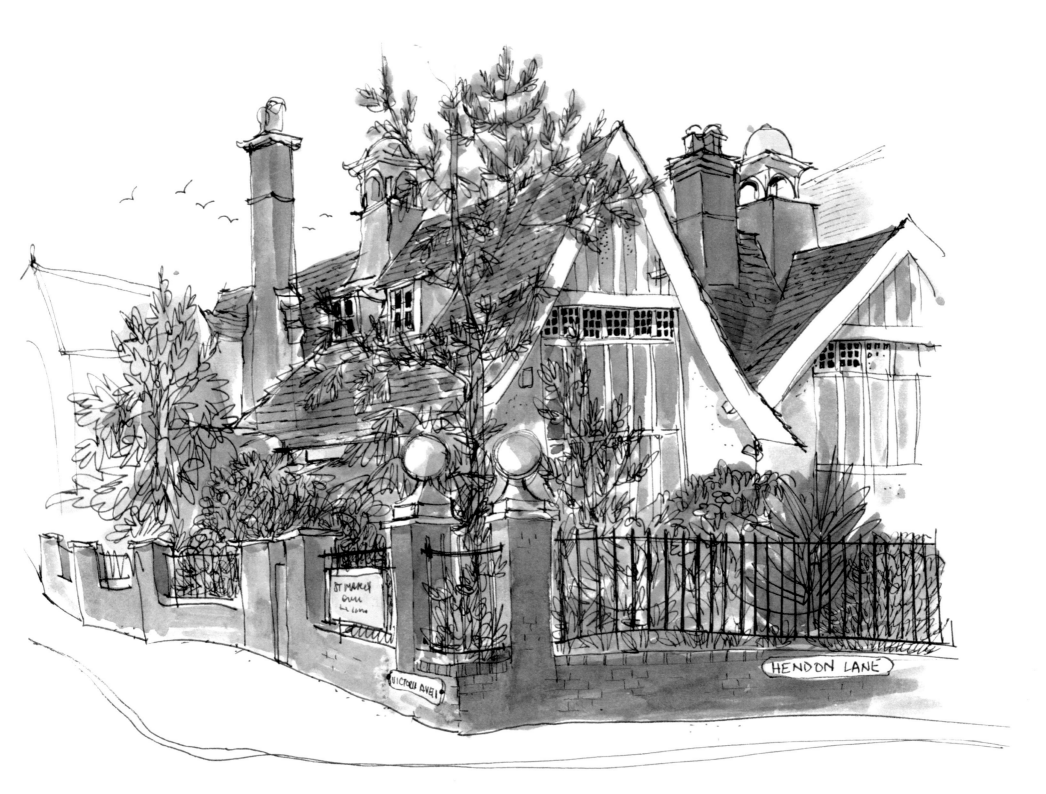

HENDON LANE

VICTORIA AVE

The Old School House

This building was originally part of old St Mary's Primary School and has been beautifully adapted as business premises. The exterior has been retained and shrubs and trees planted in front make this corner on Hendon Lane a very attractive subject for sketching. Some very fine old pine trees have been saved and are in front of the adjacent building which is now a magistrates' court.

Manor Farm Dairy once sold milk from the farm and still retains the original features. Street furniture and pizza scooters are all part of the atmosphere.

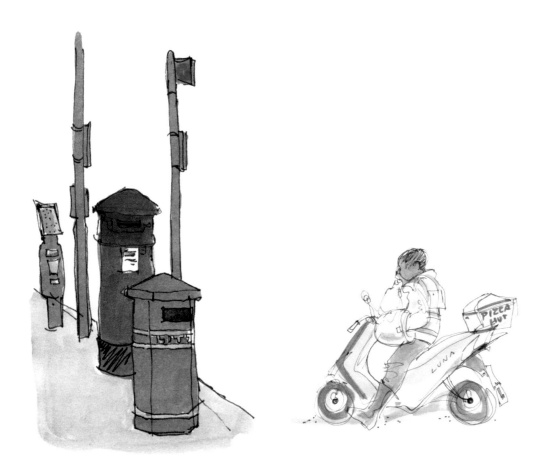

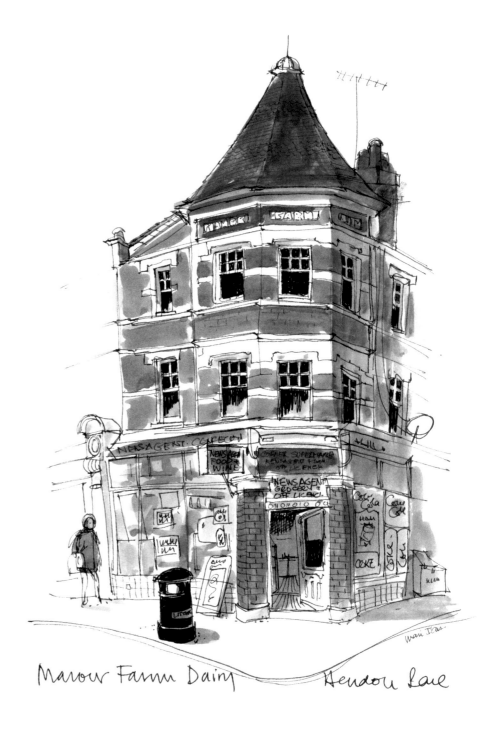

Manor Farm Dairy Hendon Lane

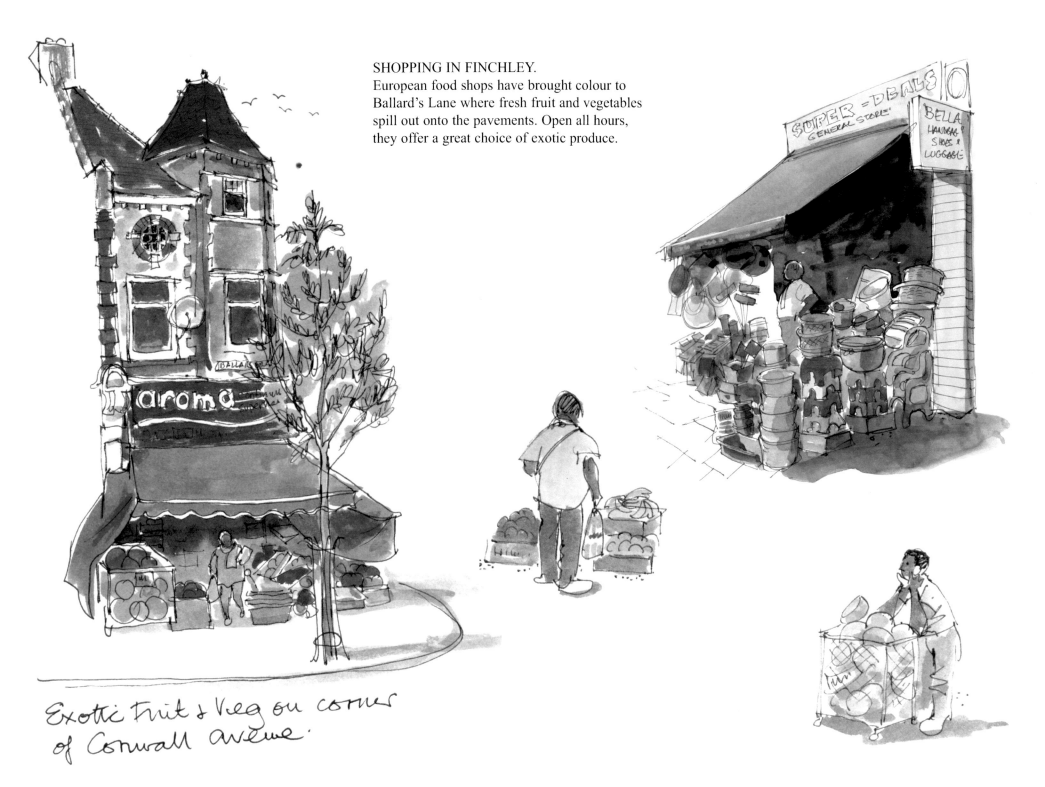

SHOPPING IN FINCHLEY.
European food shops have brought colour to
Ballard's Lane where fresh fruit and vegetables
spill out onto the pavements. Open all hours,
they offer a great choice of exotic produce.

Exotic Fruit & Veg on corner
of Cornwall avenue.

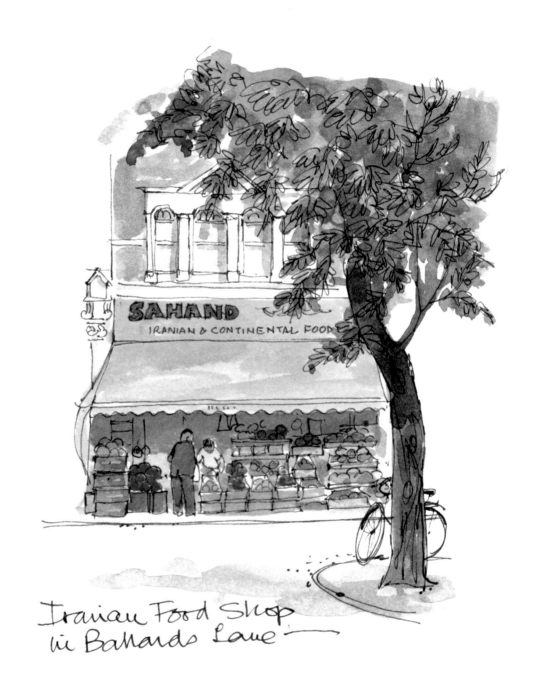

SAHAND
IRANIAN & CONTINENTAL FOOD

Iranian Food Shop
in Ballards Lane

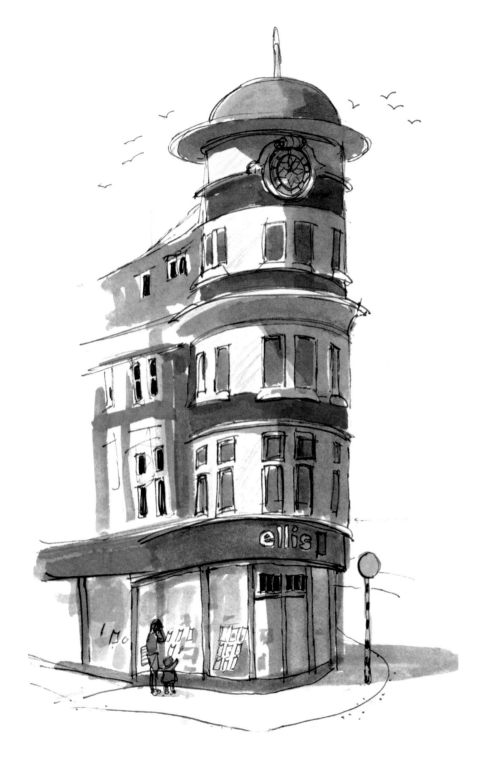

Edwardian architecture still flourishes in this area and King Edward Hall is an outstanding example. With the domed tower on the exterior and luxurious banqueting hall upstairs it really is a treasure. I remember that the shop sold gowns years ago and is now one of many estate agents in the town centre.

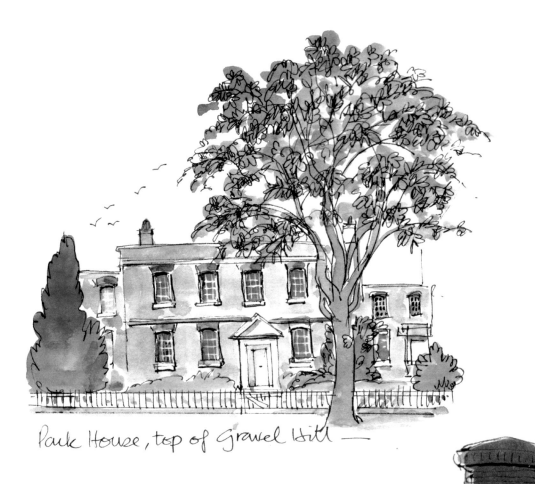

Park House, top of Gravel Hill —

Park House is an elegant Georgian house at the
top of Gravel Hill. I imagine that there must have been a beautiful
view from the house in earlier times

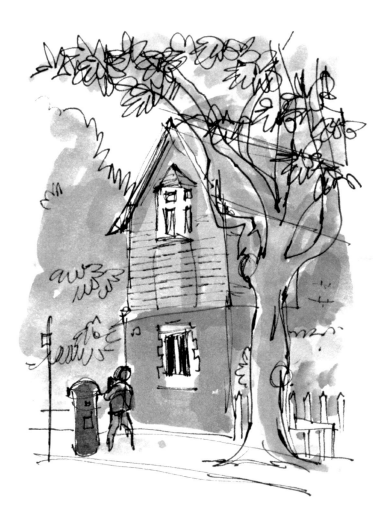

Victoriana thrives in this area with an
original pillar box on a corner of
Hendon Lane.

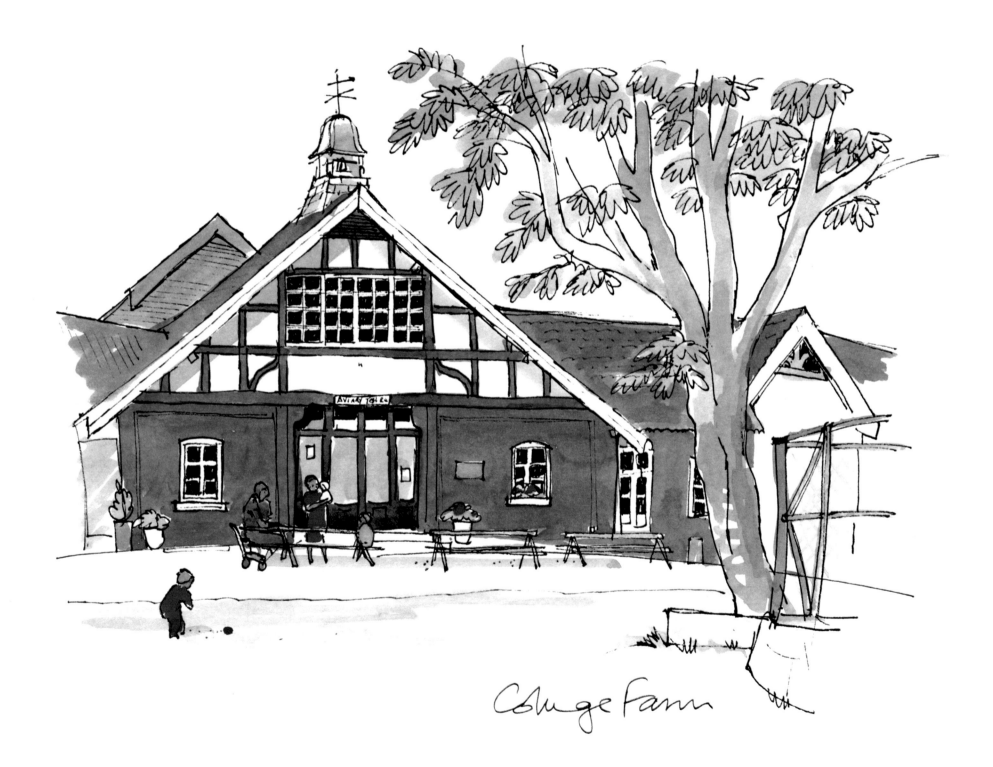

College Farm

COLLEGE FARM.
I have always had a great affection for College Farm.
I had been involved in creating an art gallery there in
the 80's where local artists exhibited their paintings
once a month, and a very popular craft market. In those
days rare breeds of farm animals were on view and
I found such a variety of inspiration for my sketchbooks.

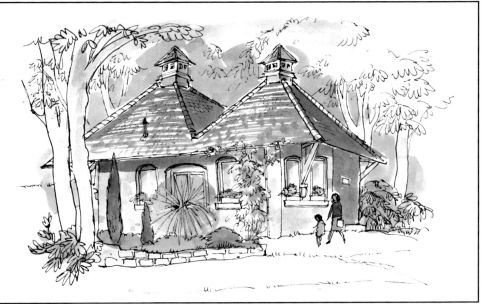

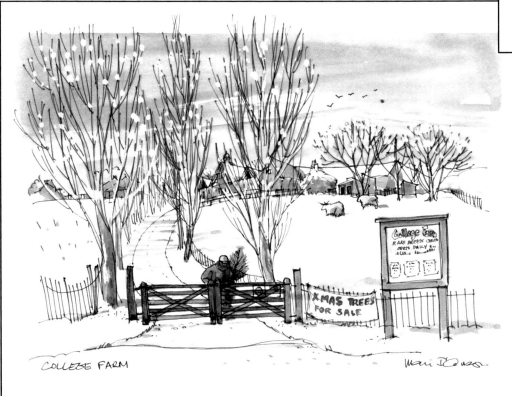

COLLEGE FARM

THE DAIRY which had been lovingly restored as
a tea house by Su Russell provided cream teas for many years.
Original Minton tiles were discovered. Vintage tablecloths and old
china recreated a taste of a bygone age.

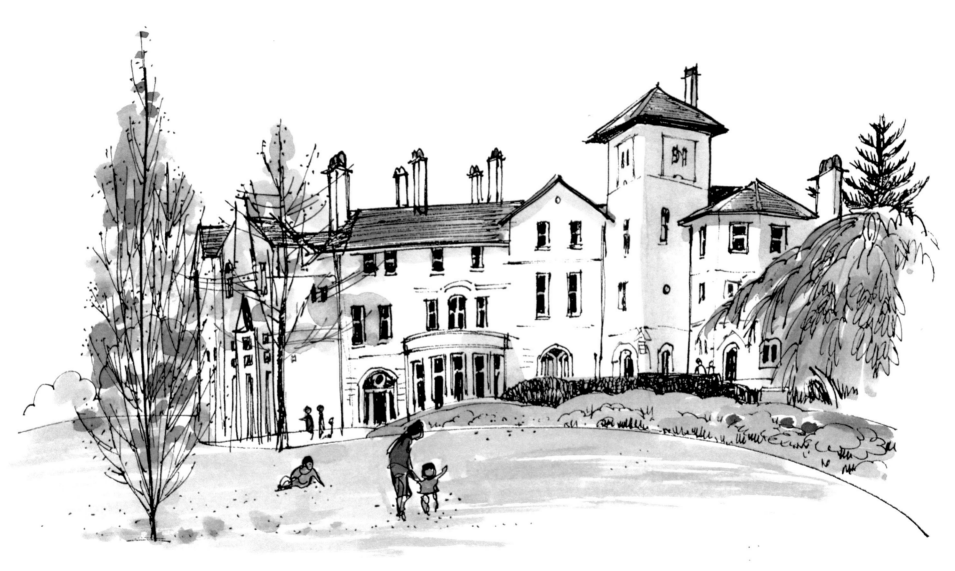

AVENUE HOUSE, FINCHLEY

AVENUE HOUSE

Henry 'Inky' Stephens lived and worked here leaving the house and grounds to the people of Finchley and has always been a good place to take my sketchbook. Not just the architecture of the house with towers, turrets and pretty windows, but the grounds with beautifully maintained flower beds and woods that are planted with a wide range of trees and shrubs.

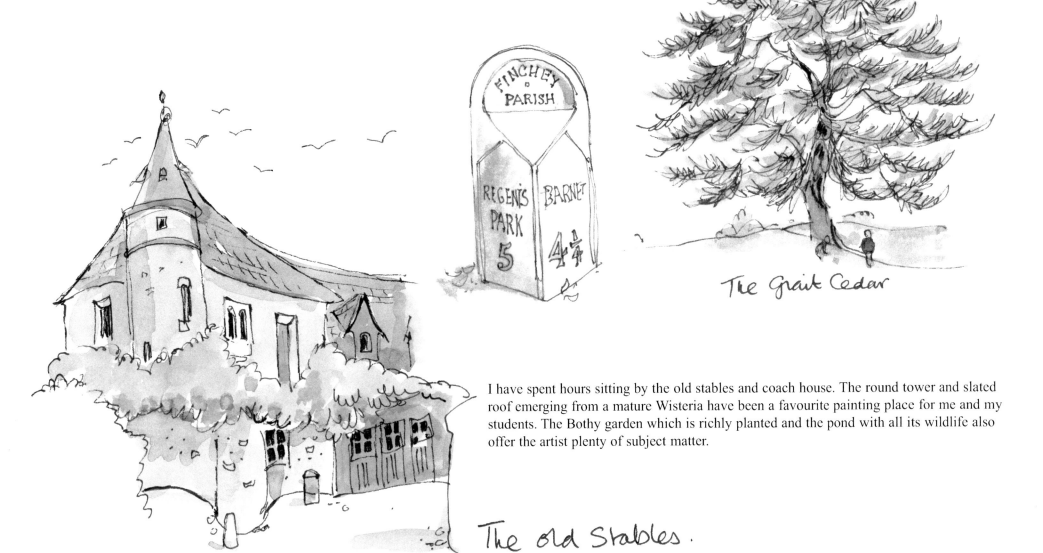

The Great Cedar

I have spent hours sitting by the old stables and coach house. The round tower and slated roof emerging from a mature Wisteria have been a favourite painting place for me and my students. The Bothy garden which is richly planted and the pond with all its wildlife also offer the artist plenty of subject matter.

The old Stables.

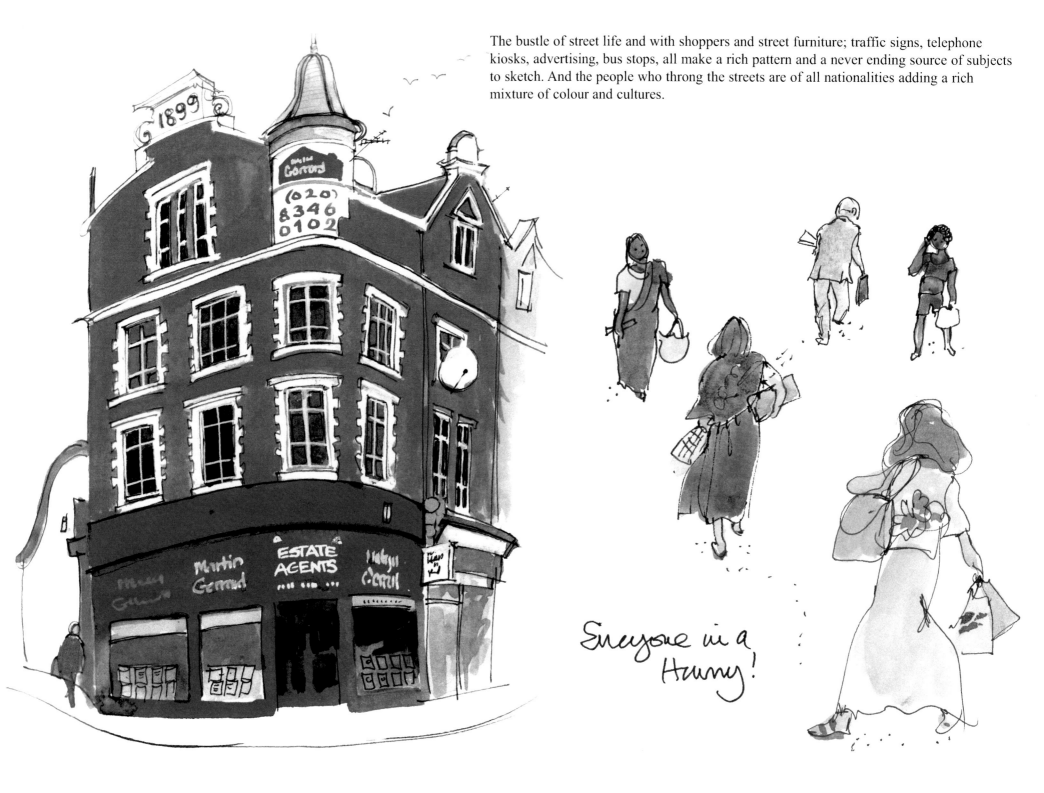

The bustle of street life and with shoppers and street furniture; traffic signs, telephone kiosks, advertising, bus stops, all make a rich pattern and a never ending source of subjects to sketch. And the people who throng the streets are of all nationalities adding a rich mixture of colour and cultures.

1899

Gerrard

(020)
8346
0102

Martin
Gerrard

ESTATE
AGENTS

Everyone in a Hurry!

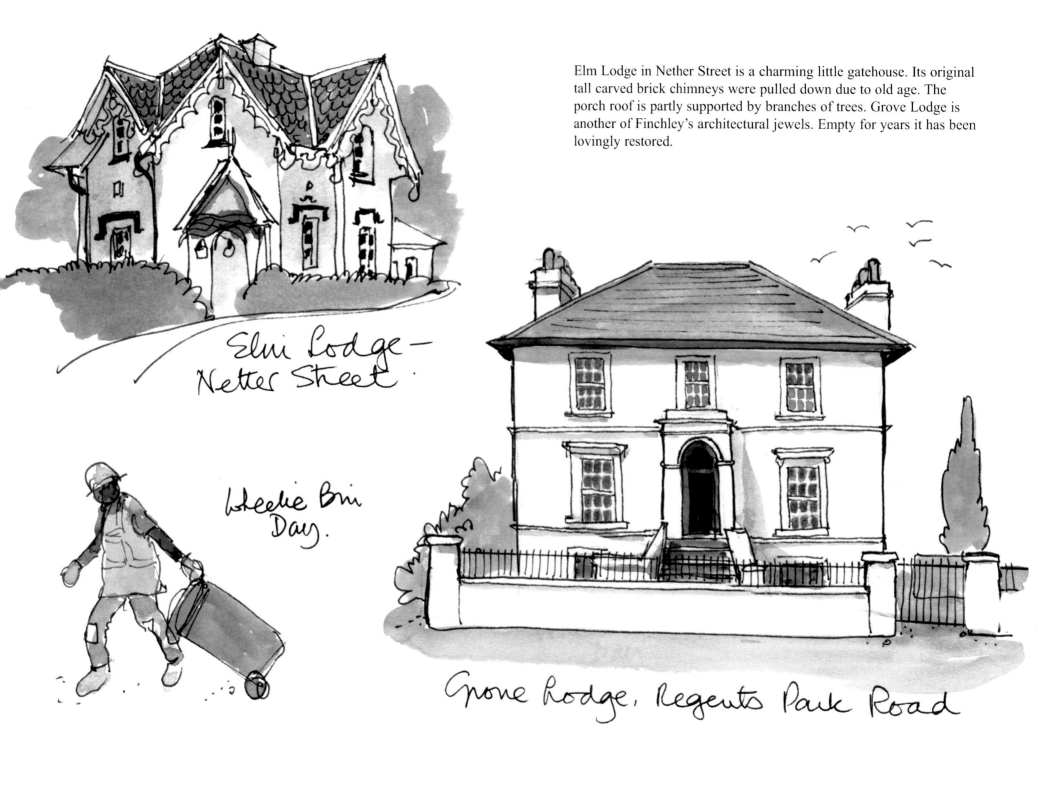

Elm Lodge in Nether Street is a charming little gatehouse. Its original tall carved brick chimneys were pulled down due to old age. The porch roof is partly supported by branches of trees. Grove Lodge is another of Finchley's architectural jewels. Empty for years it has been lovingly restored.

Elm Lodge – Nether Street.

Wheelie Bin Day.

Grove Lodge, Regents Park Road

FINCHLEY MEMORIAL HOSPITAL, was built in 1908 and has served the local community since then as a general hospital and more recently as a 'drop in' surgery. The brick and plastered walls, little bay windows and the elegant domed front porch have survived modernisation, until now. We are possibly to lose this lovely piece of Edwardian architecture as plans to create a new hospital are under way. This watercolour was commissioned to commemorate the centenary.

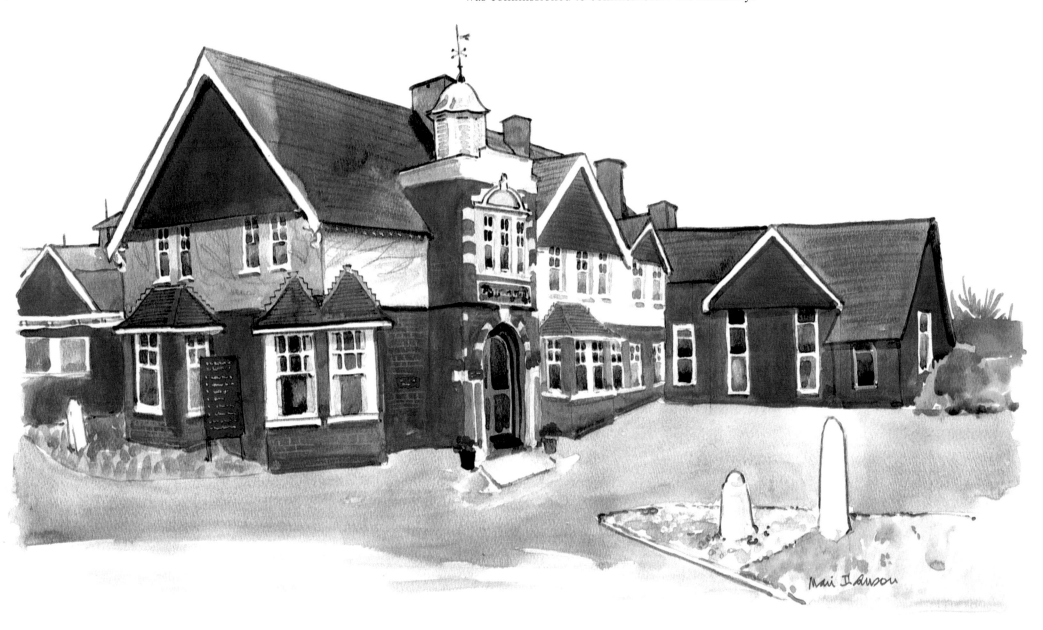

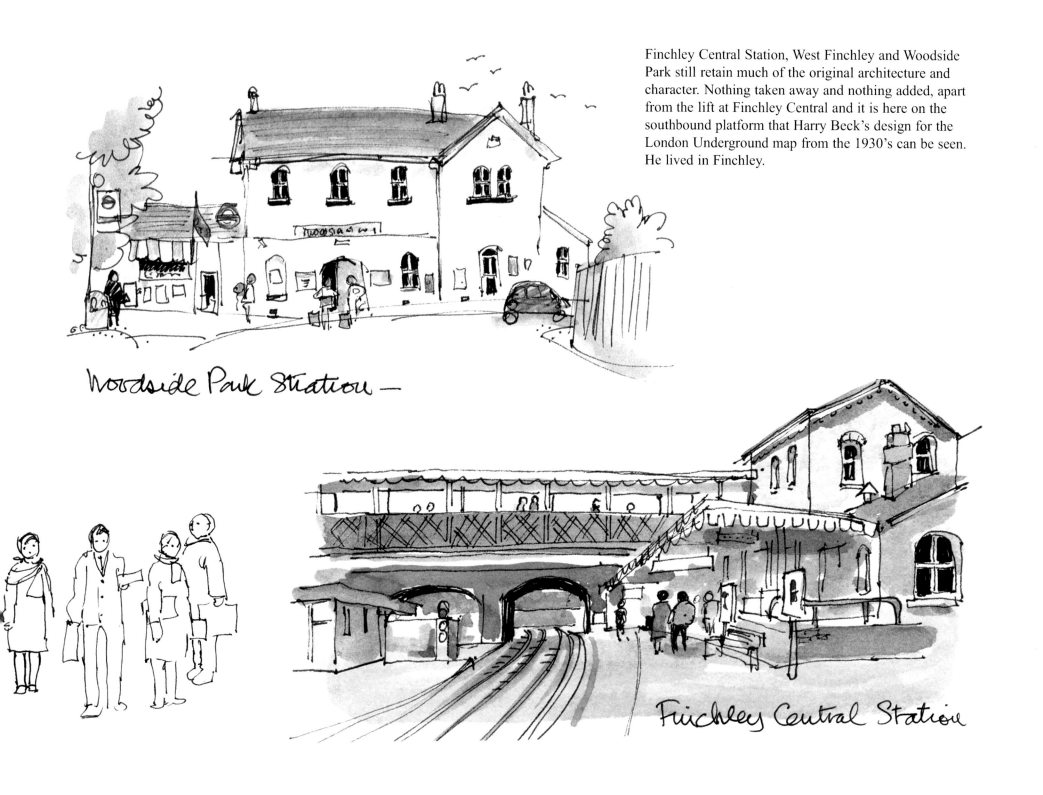

Finchley Central Station, West Finchley and Woodside Park still retain much of the original architecture and character. Nothing taken away and nothing added, apart from the lift at Finchley Central and it is here on the southbound platform that Harry Beck's design for the London Underground map from the 1930's can be seen. He lived in Finchley.

Woodside Park Station —

Finchley Central Station

The mesh ironwork of the footbridge frames the two distant bridges in a gentle curve at West Finchley Station which still retains the charm of bygone days.

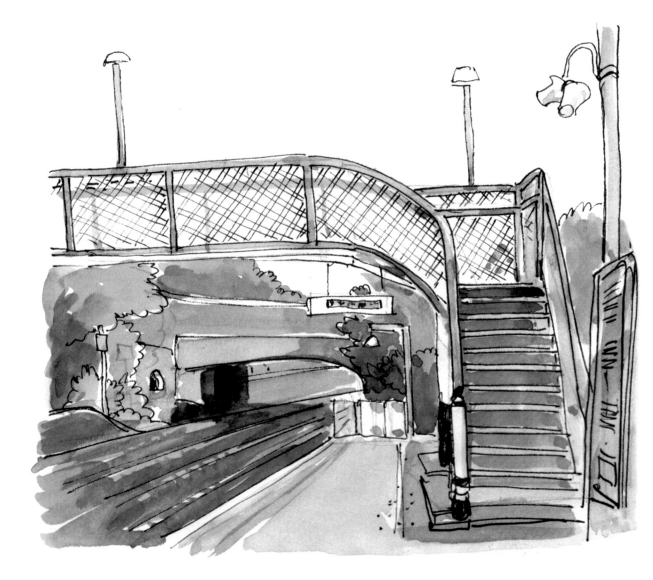

Poster Hanging

West Finchley Station

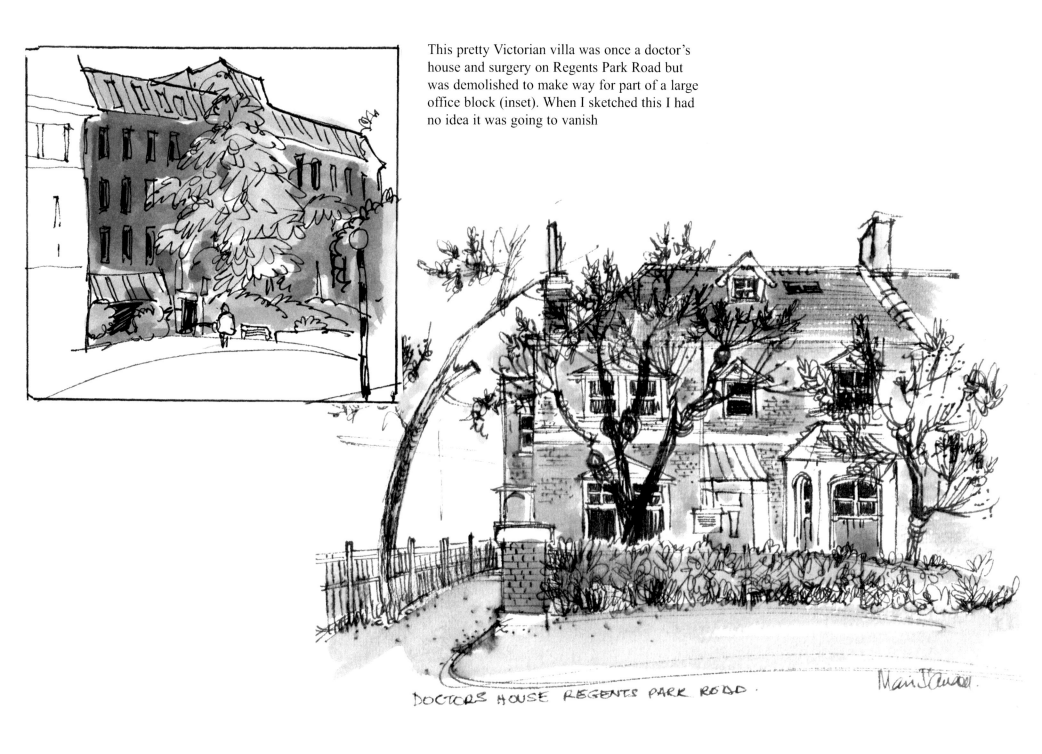

This pretty Victorian villa was once a doctor's house and surgery on Regents Park Road but was demolished to make way for part of a large office block (inset). When I sketched this I had no idea it was going to vanish

DOCTORS HOUSE REGENTS PARK ROAD.

The apartment block next door to the Methodist
Church replaces an early Victorian cottage. It
stood on the corner of Ballard's Lane and Brownlow
Road. The Gothic porch and fancy brickwork display the
artistry that the 19th century builders used to create the
homes of those days. Such a joy to sketch.

BALLARDS LANE N3

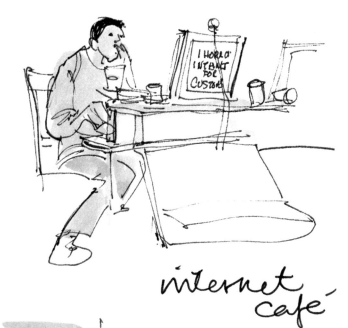

internet café

International cafes abound in Finchley. It is a great place to eat and drink. You can choose between Brazilian, Chinese, Indian, Iranian, Italian, Japanese, Turkish, Thai, or even good old fish and chips! Some have Internet. Many have outdoor areas and in the summer Finchley takes on a continental atmosphere.

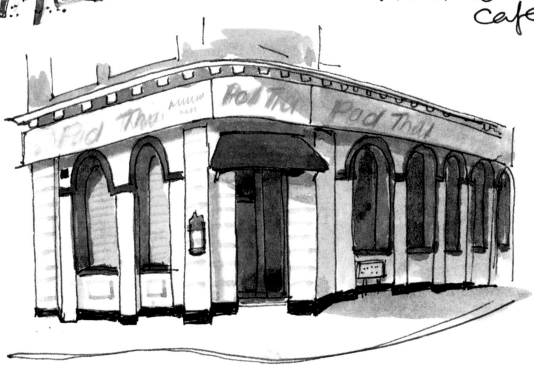

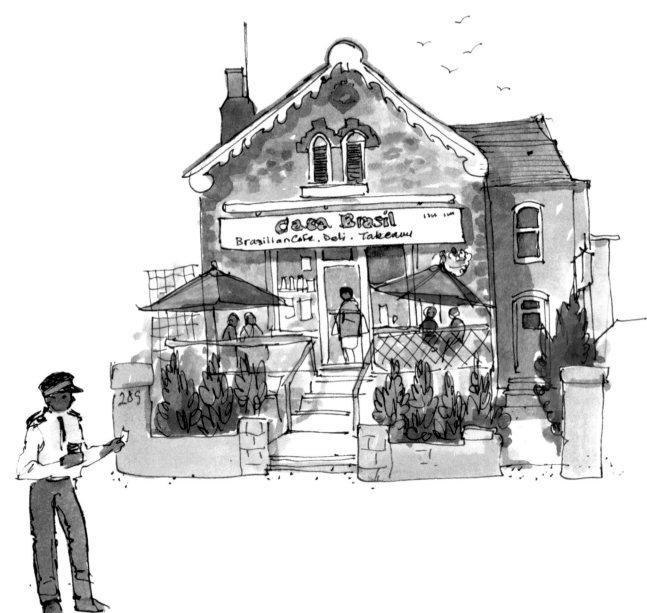

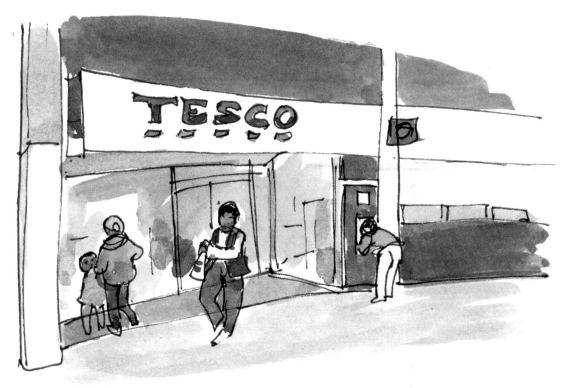

Shopping in Finchley has become a ritual when it comes to Tesco. Everything you need can be found here. When built, it replaced some small family based service shops on the main road and some cottages at the rear.

The tea house
Victoria Park

VICTORIA PARK
An open space, which is popular with children and dogs. I can spend hours here drawing people. Children on the swings, playing ball or running around.

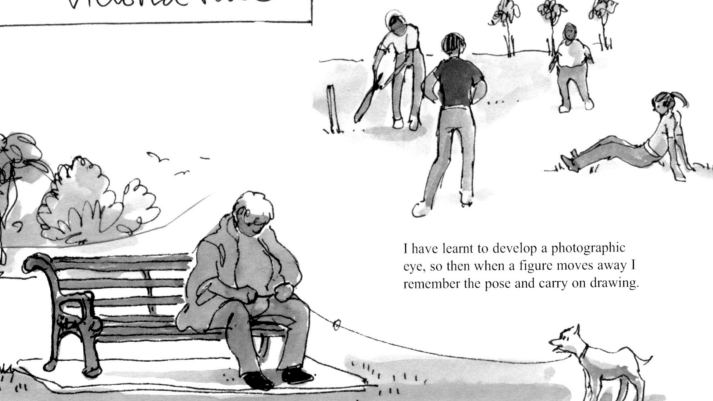

I have learnt to develop a photographic eye, so then when a figure moves away I remember the pose and carry on drawing.

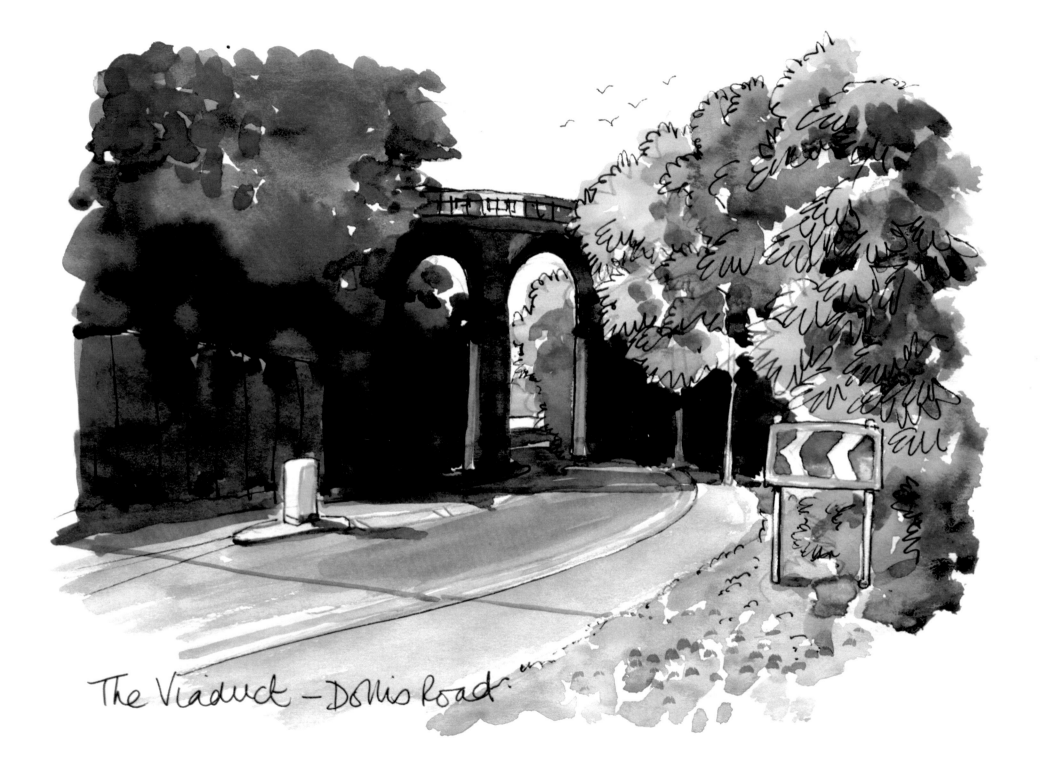

The Viaduct — Dollis Road

LA DELIVRANCE. As you leave The North Circular Road and head for Finchley, you might just notice a statue of a naked lady. This bronze was produced in France and presented to the people of Finchley in 1927.

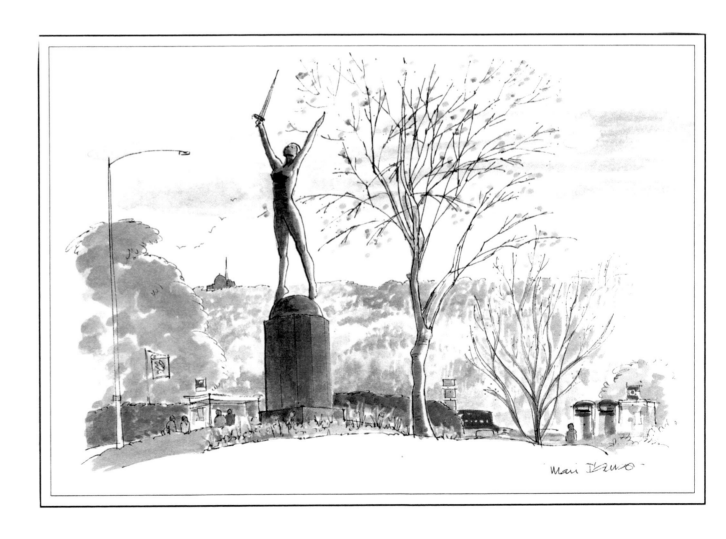

Some of Finchley's finest architecture can be seen in places of worship. The Methodist Church in Ballards Lane has a spire high enough to be seen from a distance and the original church building alongside is now the Church Hall.

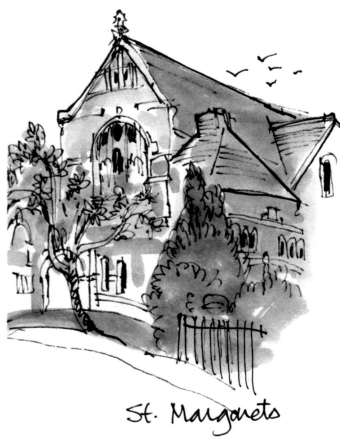

St. Margarets

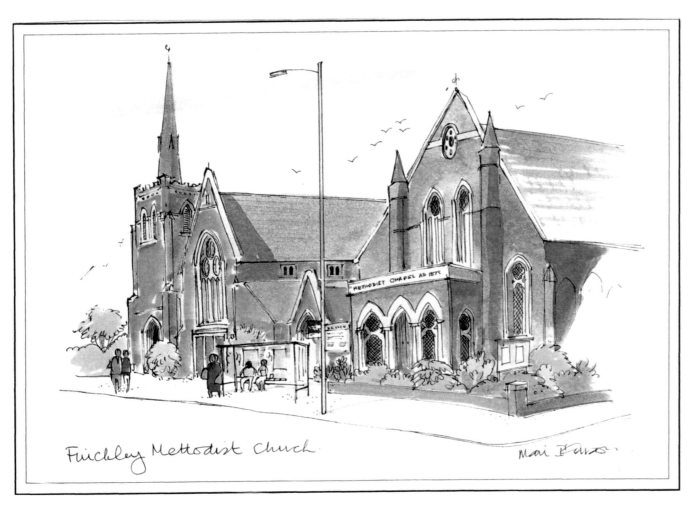

Finchley Methodist Church

St Margaret's in Victoria Avenue has an imposing west window and unusual tiled roofs.

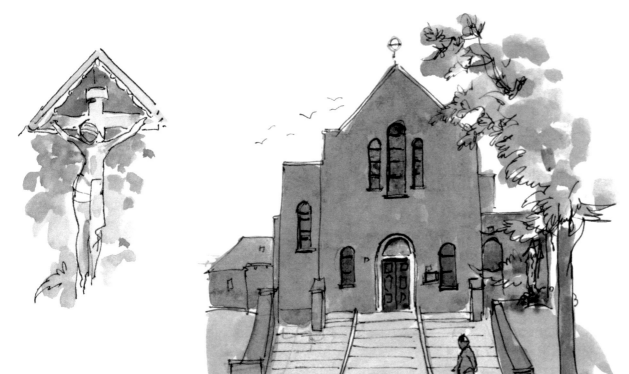

St Philip the Apostle R.C. Church

St Philip's Roman Catholic Church in Regents Park Road, St Paul's Church of England in Long Lane built of stone with angular roofs and the modern brick Synagogue in Redbourne Avenue.

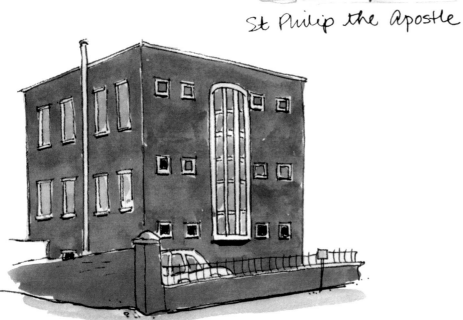

Synagogue — Redbourne Aveme

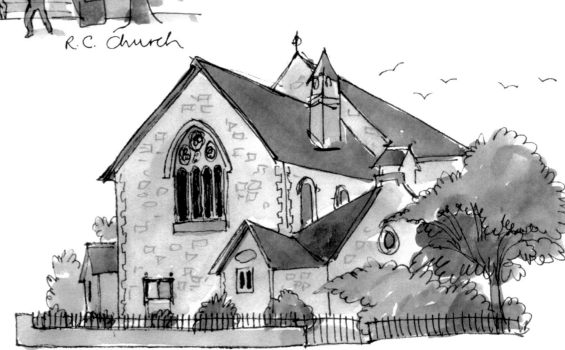

St. Pauls Church.

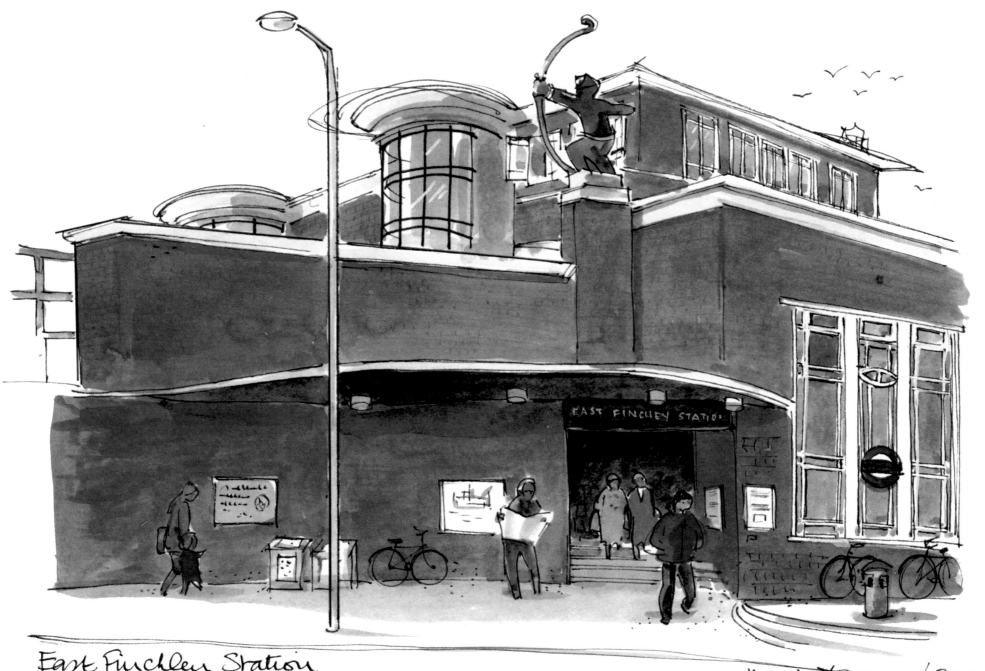

East Finchley Station

Max Benson 2000

EAST FINCHLEY STATION. The northbound Northern Line emerges into daylight at this art deco station with a statue of an archer pointing his bow towards Cherry Tree Woods. The waiting rooms have the original 1930's bow-fronted windows. Since I drew this, fruit and flower stalls have been set up on the station forecourt.

The Phoenix Cinema was built in 1910 opening as The Picturedrome. It was later called the Coliseum and I remember it as The Rex. It has continued to screen films until the present day showing the latest releases and art films. In the auditorium gold painted bas relief wall decorations are of special interest.

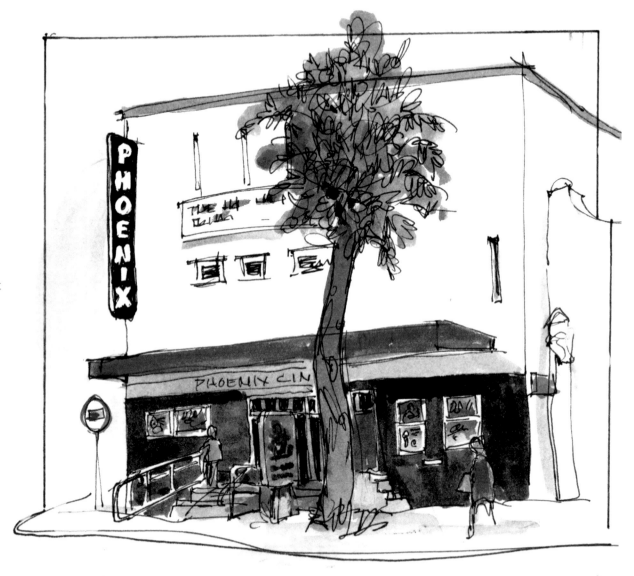

The Phoenix Cinema - Built 1910

The East Finchley High Road is a busy thoroughfare. A French style kiosk surrounded by shrubs and a bicycle rack add a continental flavour. This is an area where shopping is a pleasure. Small food shops, delicatessens, smart household goods, florists and gifts, a good bookshop, a fishmonger, patisseries, cafes and art galleries.

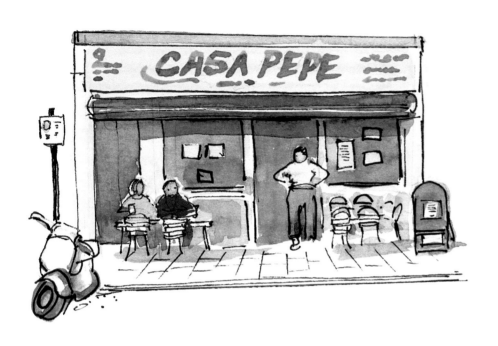

CASA PEPE

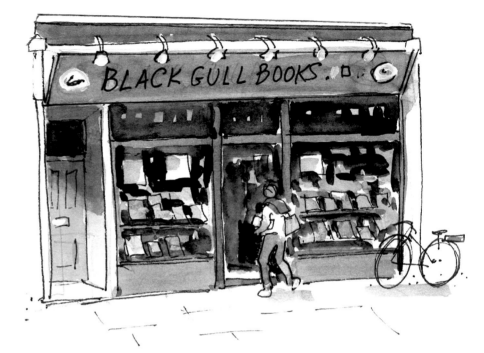

BLACK GULL BOOKS

TONY'S CONTINENTAL

ANY'S

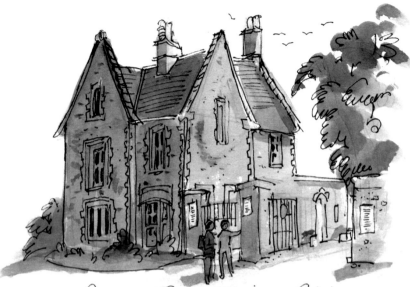

St. Pancras Crematorium Gatehouse

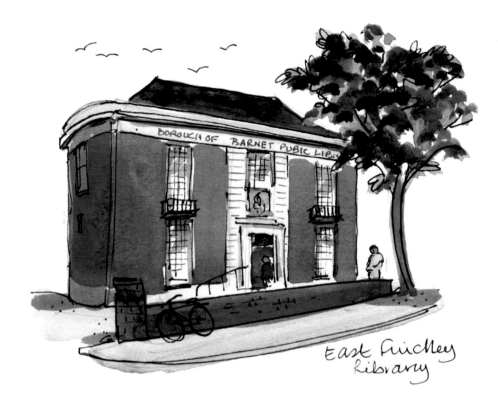

East Finchley Library

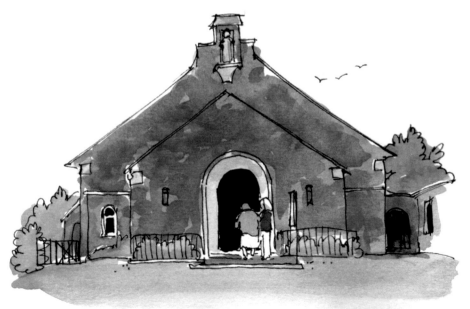

St. Mary's Roman Catholic Church N2

Red and yellow brick has been a dominant feature of many of our local public buildings. East Finchley Library and St Mary's Catholic Church are typical examples. The stone gateway of St Pancras Crematorium forms a majestic entrance into a beautiful place of peace and bird life. There are some interesting tomb sculptures.

East Finchley Methodist Church is good example in the late Victorian style. I was commissioned to paint this watercolour by the church a few years ago as a parting gift for a church member.

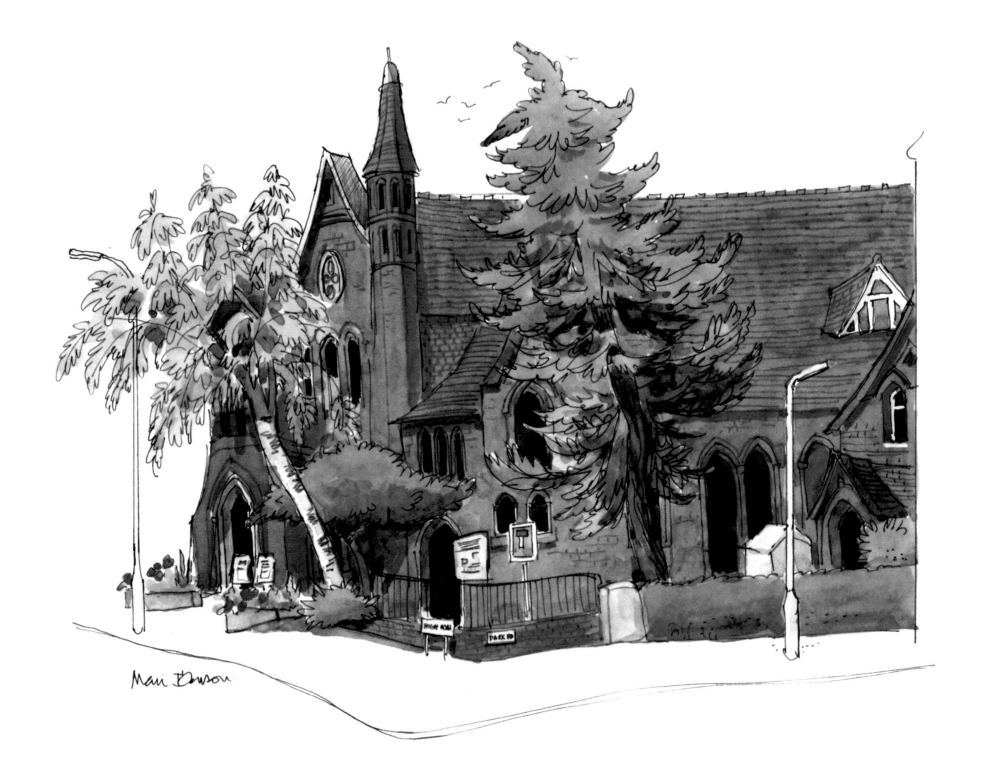

HIGH ROAD

PARK RD

A converted church has become a popular arts centre for local young people. Although of similar pastel colours it is a contrast in design to the block of flats I noticed from the High Road.

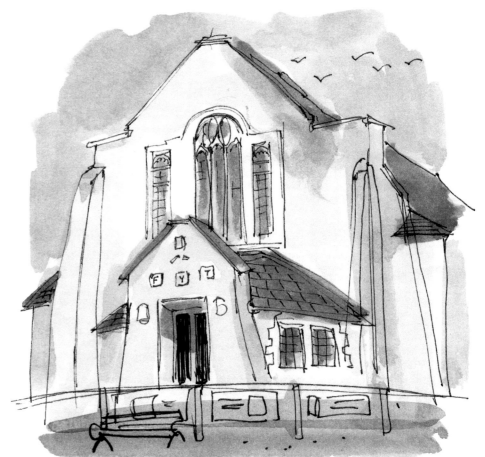

East Finchley Youth Centre

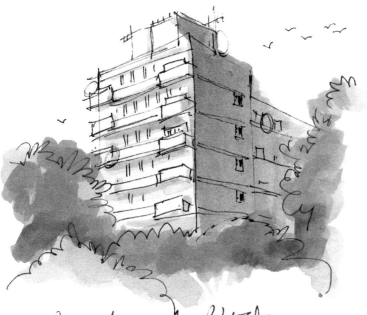

apartment block

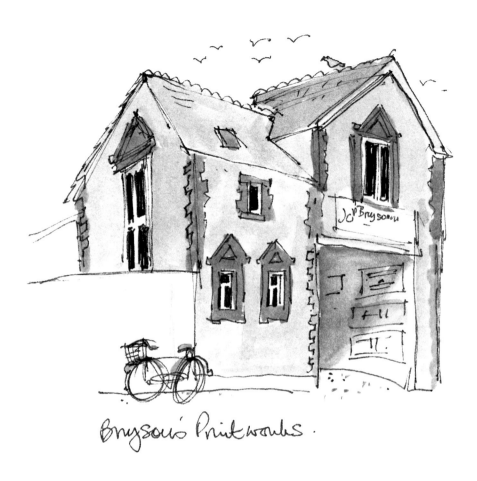

Bryson's Printworks.

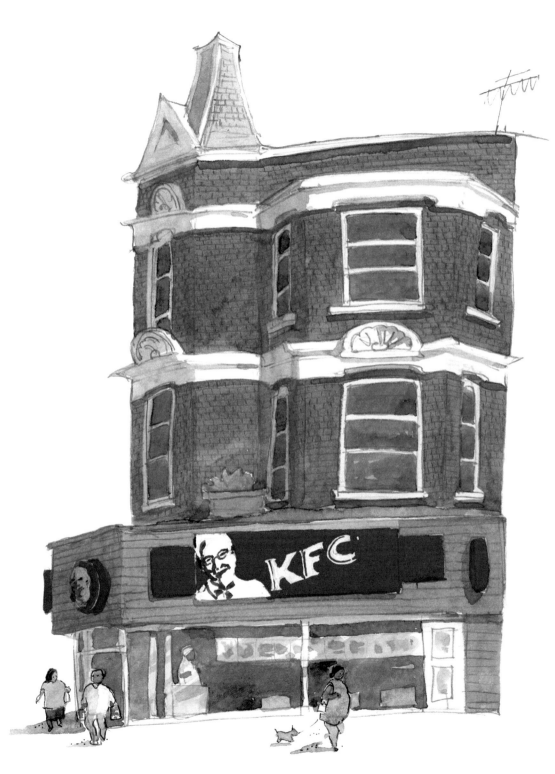

The entrance in Huntingdon Road to JG Bryson's printing works. This lovely example of red and pale yellow brick once housed the stables serving the shops in the High Road. Inside, they still have some of the original printing presses and machinery.

By taking a good look above the shops I discovered some interesting decorative stone carvings and red brick like this example above KFC in the High Road.

The Bald Faced Stag has been a landmark for centuries. This Victorian public house is one of a series of coaching inns for travellers going north. It was on the southern edge of Finchley Common.

High Road East Finchley.

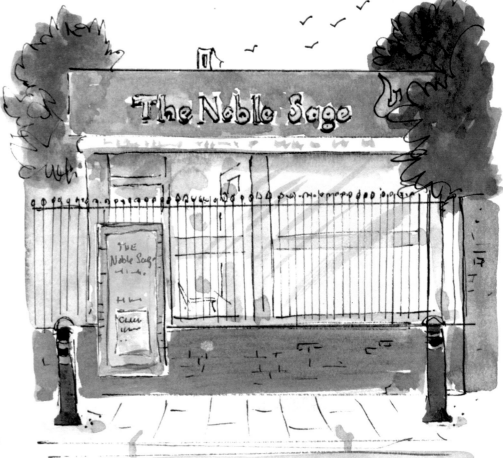

Street life in the High Road is lively. Flower stalls and a weekly market give me plenty of subject matter for my sketchbooks. People on the move don't worry me. I can still remember the poses long after they've gone. I have exhibited some of my paintings of India at The Noble Sage Gallery that specialises in Asian art.

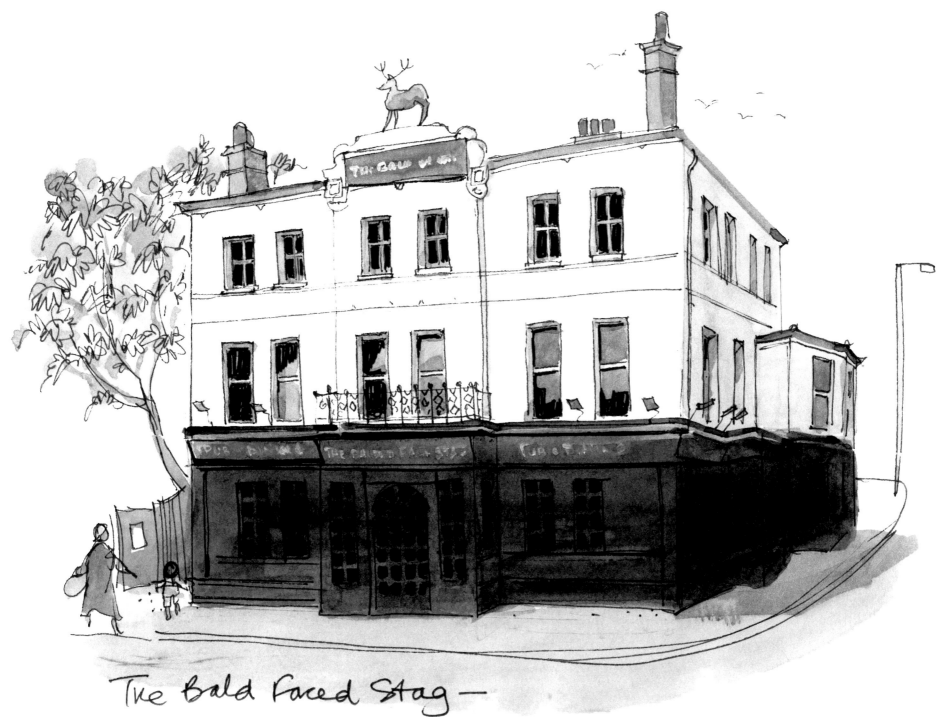

The Bald Faced Stag —

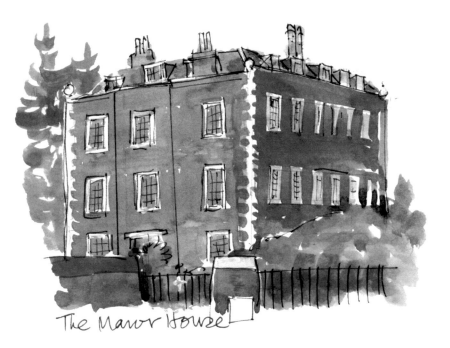

The Manor House

The Manor House in East End Road, now
The Sternberg Centre for Judaism, stands next door
to St Theresa's R.C. Primary School.
LA Fitness shares ground with the local cricket club.
I particularly love the pointed arches leading into the
St Marylebone Cemetery.

L.A. Fitness. East End Road.

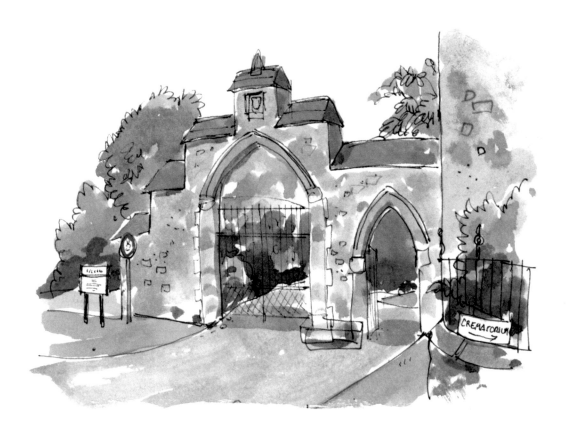

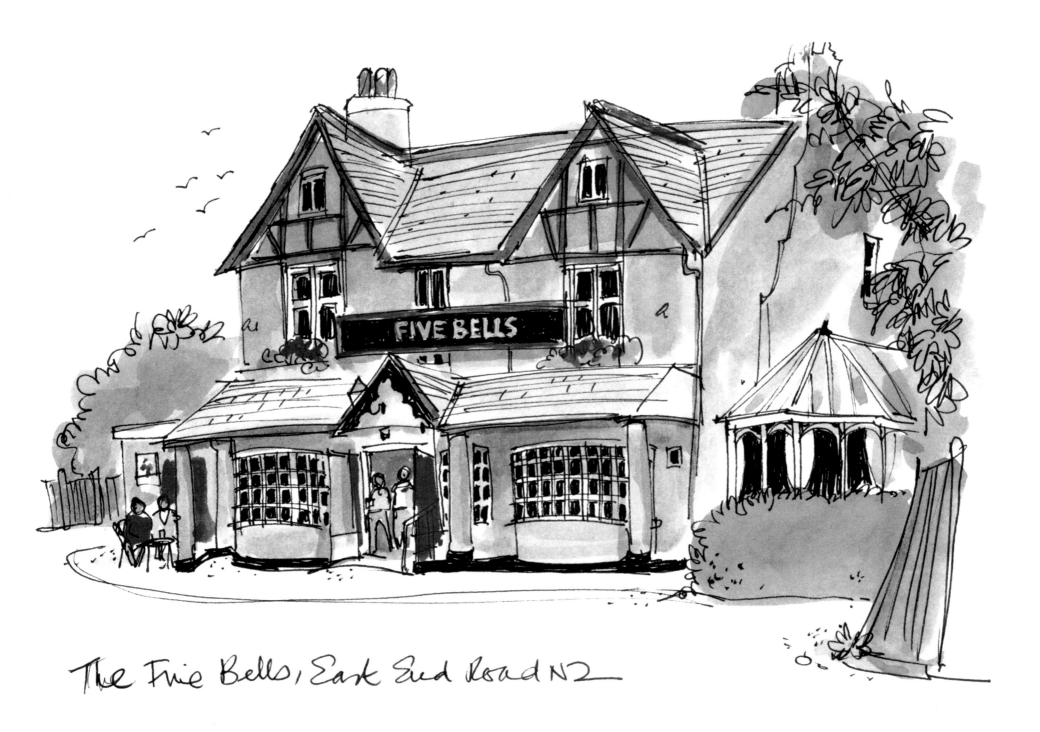

FIVE BELLS

The Five Bells, East End Road N2

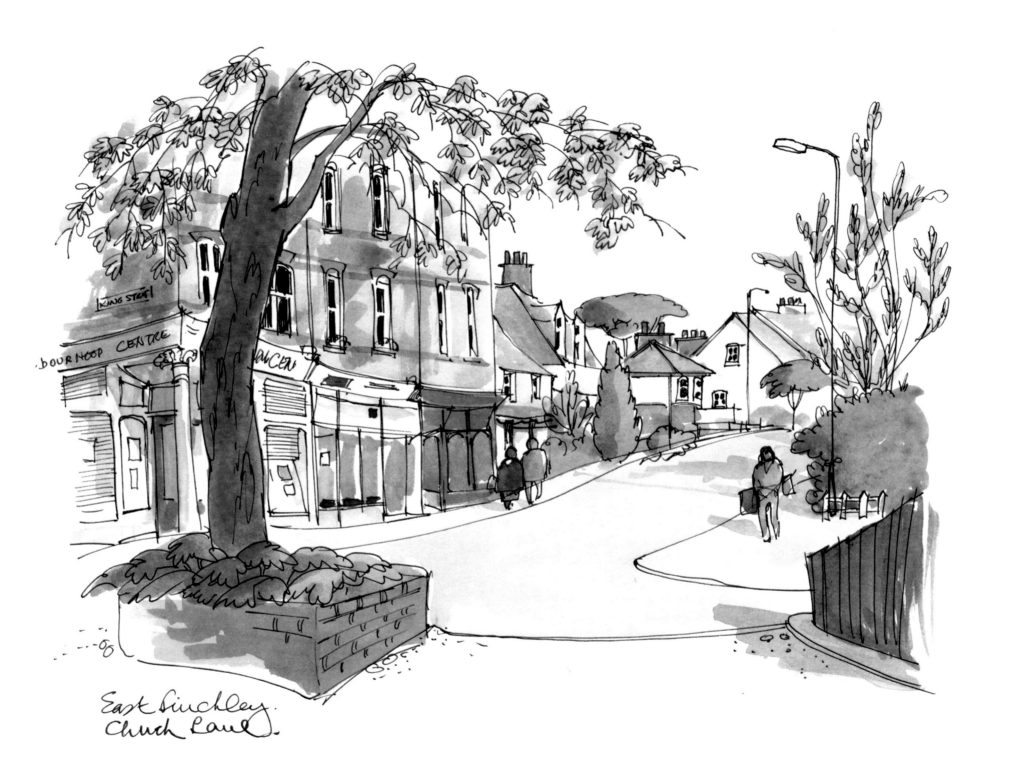

KING STREET

NEIGHBOUR CENTRE

East Finchley.
Church Lane.

East Finchley Village is based around the top of Church Lane. Some small shops and the Neighbourhood Centre give this place a sense of community. I only managed to sketch part of Holy Trinity Church which was visible through the thick forest of trees. There are some pretty cottages in the side streets. This area has been greatly improved with planting of small trees and flower beds.

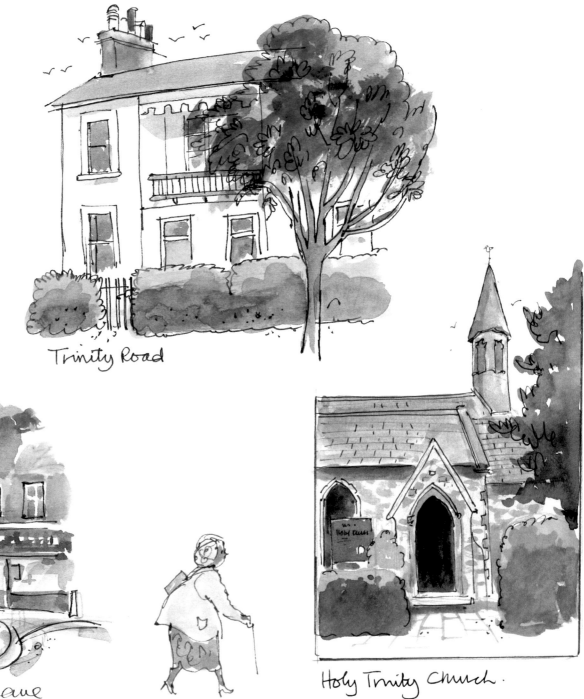

Trinity Road

Holy Trinity Church.

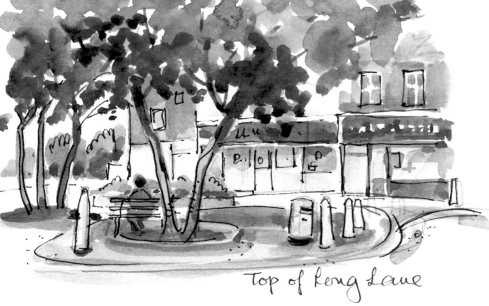

Top of Long Lane

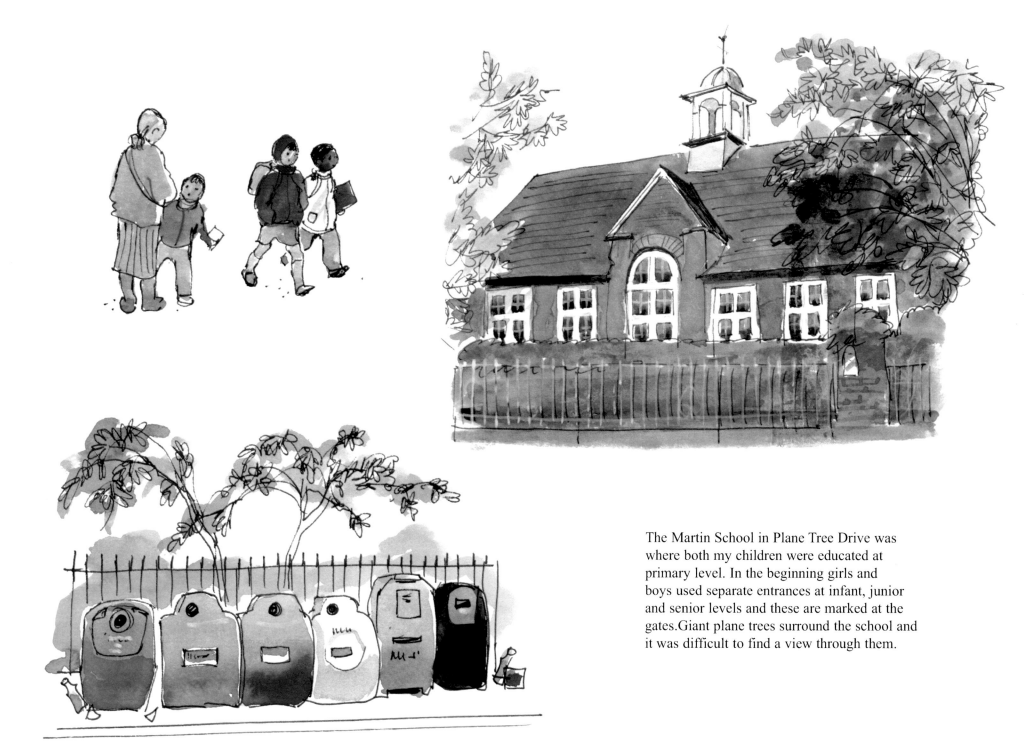

The Martin School in Plane Tree Drive was where both my children were educated at primary level. In the beginning girls and boys used separate entrances at infant, junior and senior levels and these are marked at the gates. Giant plane trees surround the school and it was difficult to find a view through them.

I was sad to see that The Red Lion pub, a charming Edwardian public house, which I had sketched in 1999 had been replaced by a modern block of flats, altering the character of this corner of the village.

Red Lion Hill

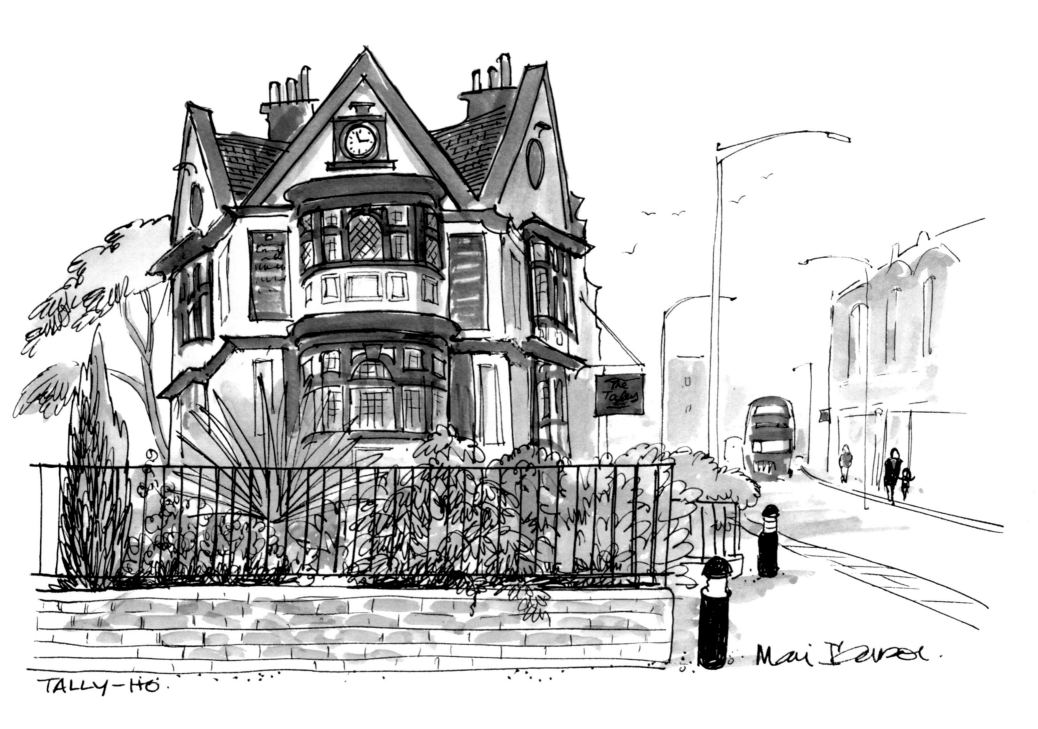

TALLY-HO.

Mai Denroe.

The Tally Ho public house is the third to be constructed on this site. I drew this prior to the artsdepot being erected. The trees and shrubs in front have grown a lot higher in recent years, but I had a clearer view of it at that time.

Trinity Church in Nether Street has a thriving community centre. Many activities take place here including the Finchley Art Society who hold their portrait classes and exhibitions in the hall. Next door, classical concerts are frequently performed in the church. In this drawing the tall steeple is dwarfed by one of the many nearby office blocks.

The artsdepot is our local centre for the arts with a towering block of flats visible for miles around. The views from the top are amazing. There are two concert halls, classrooms and studios; spaces for music, dance and drama and also a gallery and foyer space for art exhibitions. I recently had an exhibition of my own there.

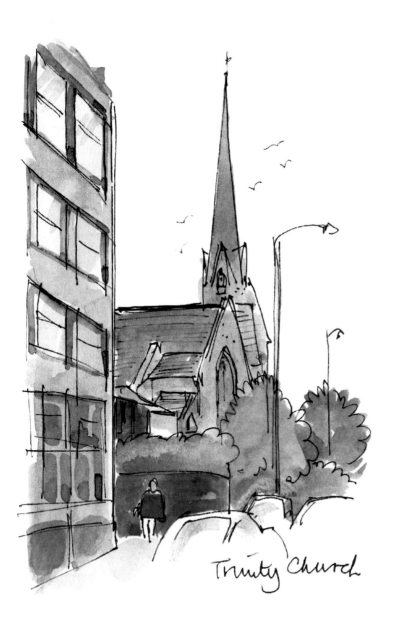

Trinity Church

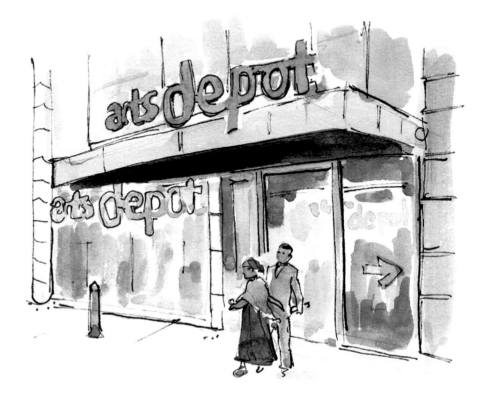

The old and the new. North Finchley library has this beautiful front porch of carved stonework. In contrast, Sainsbury have used yellow and orange brick, which does blend in quite well with the surrounding shops.

The imposing doorway of North Finchley Library.

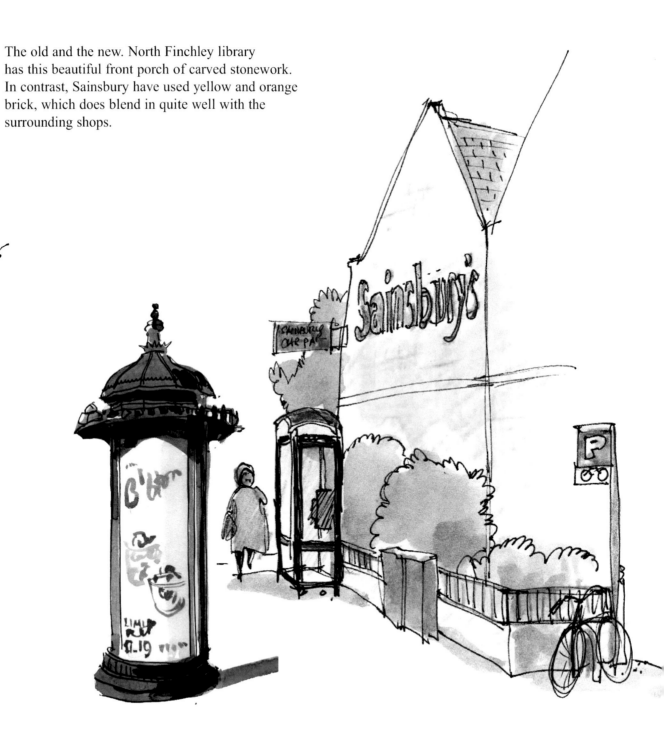

A small whitewashed cottage that was once a framing shop is now a computer office. A sign of the times. Looking above the Abbey Bank I noticed this rare example of 30's design in grey and white with long windows. It was a joy to draw. Waterstones bookshop has curved art nouveau window frames.

Computer Warehouse, Perry Road

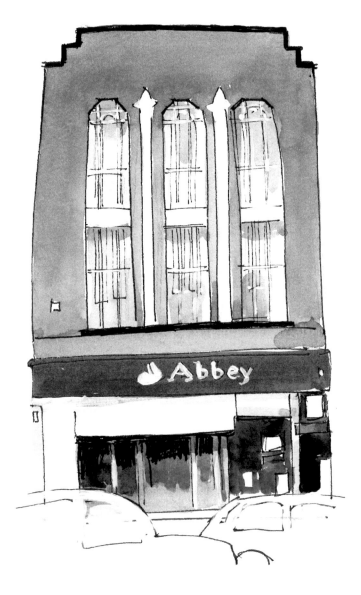

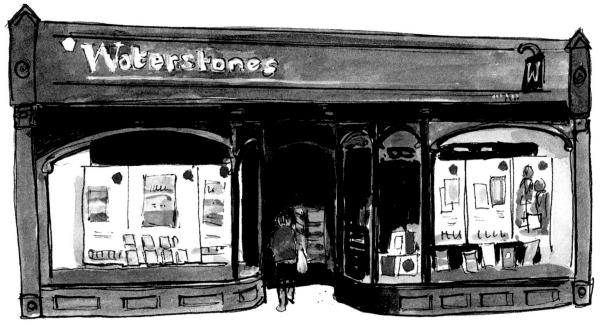

Waterstones.

North Finchley has an abundance of architecture which you can see above shop level. The High Road N12 has a great range of Victorian and Edwardian architecture. Coffee Republic has three storeys of bay windows in lovely old brick above the café, a contrast to the dark shop front below.
Café Buzz is also eye catching with red paint and gilt lettering.

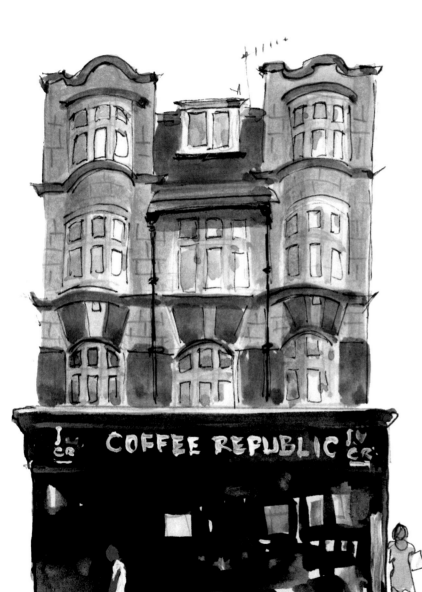

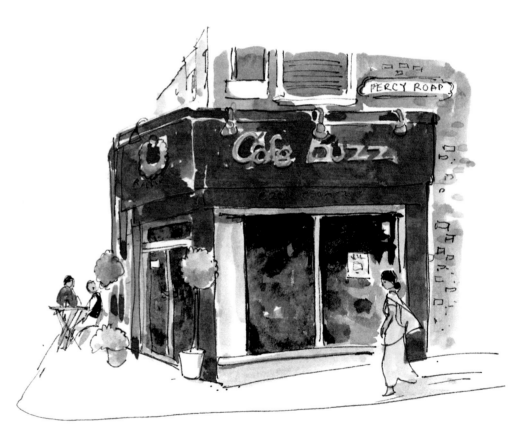

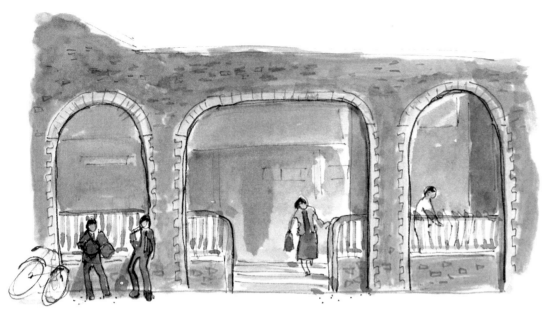

Part of the colonnade at Sainsbury where schoolboys enjoy a snack.

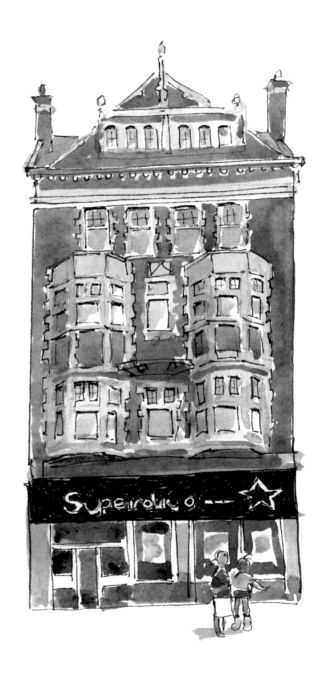

The Superdrug store is dwarfed by the four storeys of solid brickwork and the decorative gabled rooftop. This is a great example of Edwardian architecture at its best. I loved drawing this one. Although not easy to work on, it was well worth the effort.

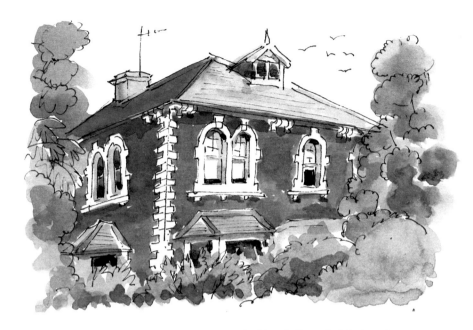

I saw this Victorian cottage surrounded by foliage in Nether Street and just had to sketch it.

The Picture Factory in Birkbeck Road, a converted stable block with a very pretty courtyard garden. This is where I often have my paintings framed and have held exhibitions in their gallery. The cobbled path leading up to the showroom is surrounded by small flowering trees and shrubs, potted plants and statuary.

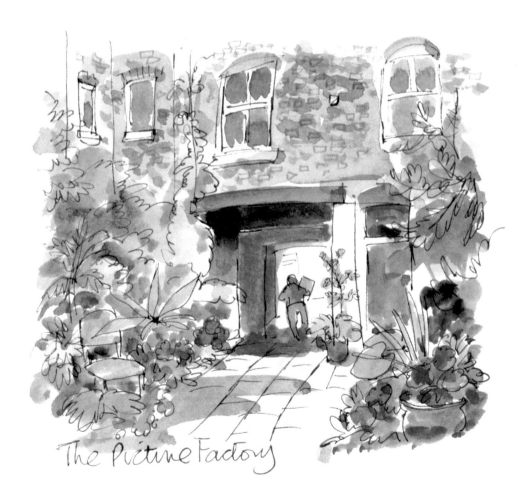

The Picture Factory

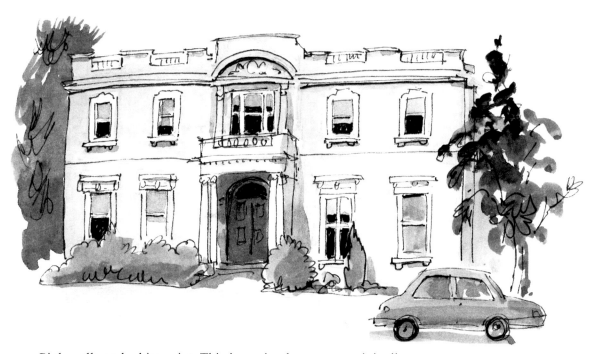

Pink walls and white paint. This imposing house was originally a gentleman's residence and is now part of Woodhouse College. My daughter attended it when it was a grammar school and before it became a sixth form college. Many extensions have been made since her days there.

NORTH LONDON HOSPICE

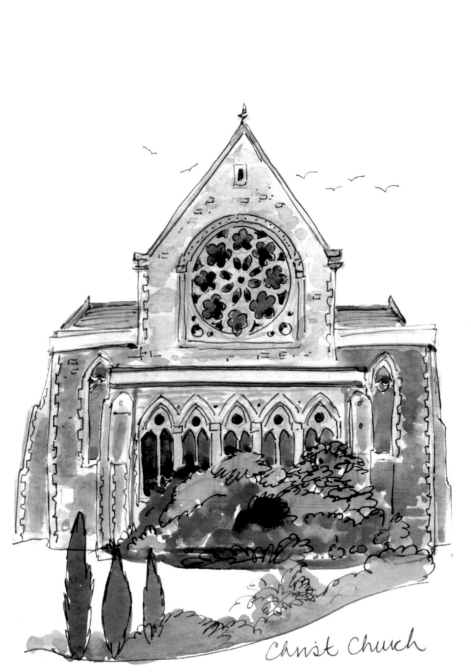

Christ Church

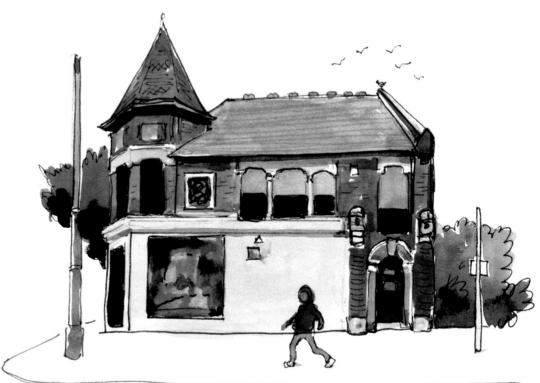

The outstanding rose window on the pointed west wall of Christ Church. Below it, five perpendicular windows at ground level and flying buttresses: this church has it all.

Across the road, this was once a shop. With tiled pinnacle, red brick and fancy stonework it's a gem. Pity about the mirrored windows!

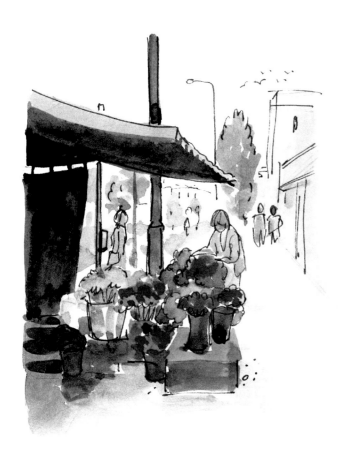

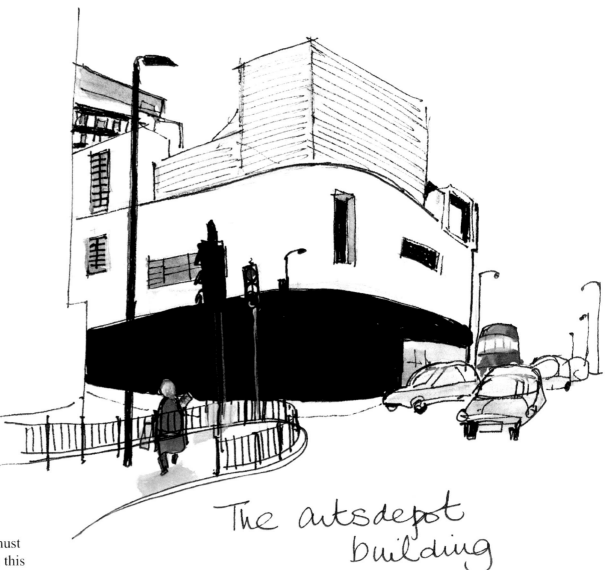

The artsdepot
building

The south side of the artsdepot building. The curved wall must be a tribute to the shape of the old cinema which stood on this site before being demolished in spite of public outcry. The Gaumont was one of the last 1930's cinemas to go. The interior was typical of the period with soft carpets and art deco decorations. The site was used for many years as a market before plans for the artsdepot were put into action.

Flower stalls add colour to the streets.

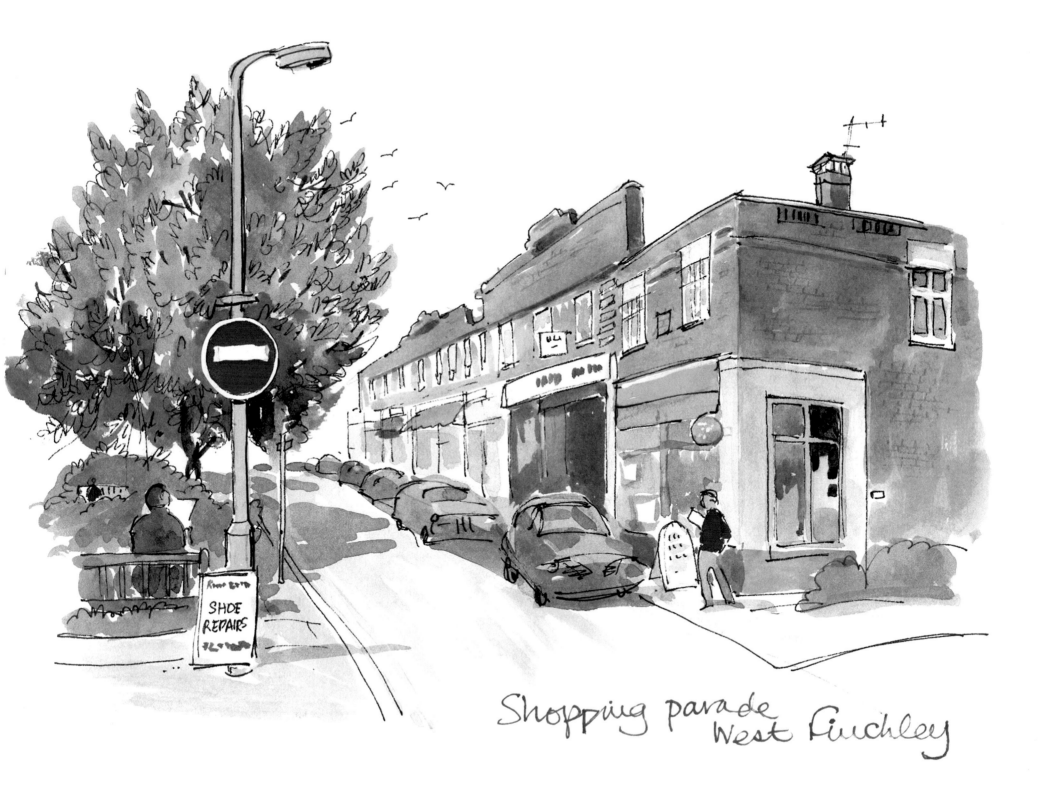

SHOE
REPAIRS

Shopping parade
West Finchley

Moss Hall Primary School

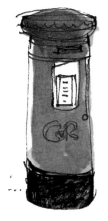

The shopping parade in Nether Street next to West Finchley station is a good example of building between the wars. The closer I looked above the shops, the more I was aware of the patterned brickwork.

The pillar-box dates from the reign of George VI.

Moss Hall Primary School is built on the site of a large old house which gives the school its name. The building has been extended in the last few years since my daughter was a pupil there. It has a huge playing field and many mature trees.

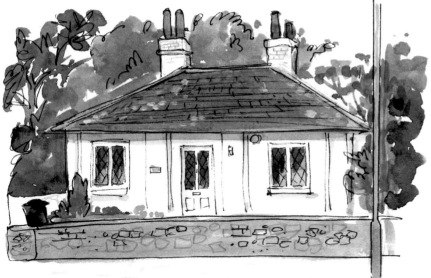

I saw this charming Victorian cottage down a side turning in Nether Street and went to investigate. I remembered that it had been a garden centre some years ago and this must have been the owner's home. The gabled roof and tall chimney stack make this a very attractive house.

200 Nether Street is a cute bungalow on the corner where Lovers Walk leads down to the brook. With tall chimneys and mullioned windows it is unique in an area where red brick predominates.

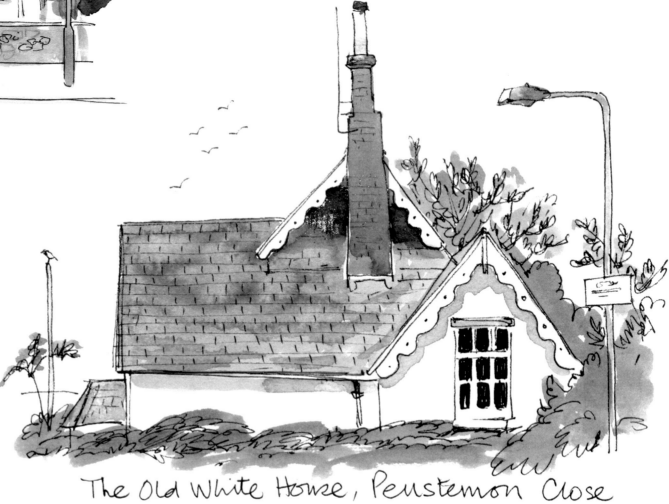

The Old White House, Penstemon Close

A semi-detached late 19th century villa
with charming doorways and balconies.

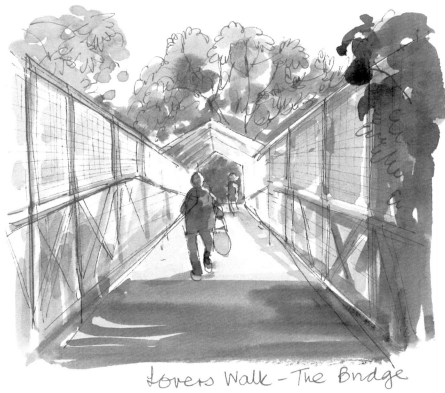

Lovers Walk – The Bridge

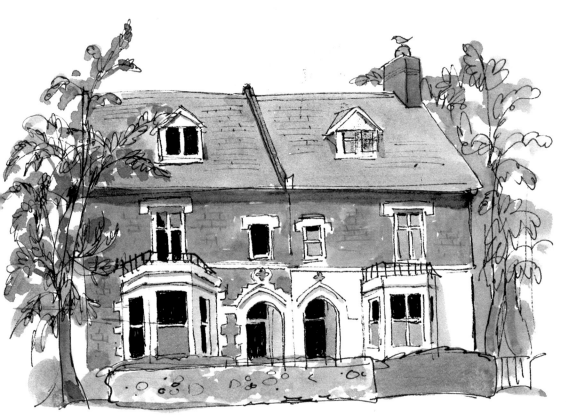

Lovers Walk; which runs downhill from Ballard's Lane
to the Dollis Brook crosses over the railway line and has
been reinforced with mesh for safety reasons. Here, I
caught the late afternoon sunlight, the shadows seemed
to frame the picture.